The Cross

ITS HISTORY
& SYMBOLISM

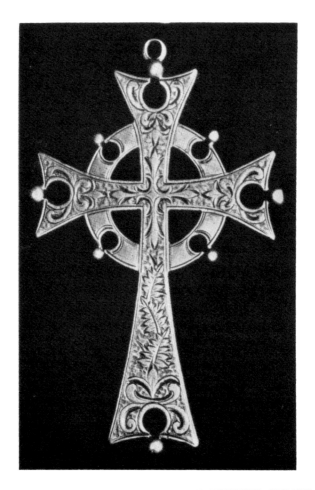

THE CHRISTIAN CROSS WITH ENTWINED CIRCLE
(Symbol of Eternal Life)

✠ THE ✠
CROSS

ITS HISTORY
& SYMBOLISM

AN ACCOUNT OF
THE SYMBOL MORE
UNIVERSAL IN ITS
USE AND MORE IM-
PORTANT IN ITS
SIGNIFICANCE
THAN ANY OTHER
IN THE WORLD.

By GEORGE
WILLARD
BENSON

Hacker Art Books,
New York, 1976.

First published Buffalo, N.Y., 1934.
Reissued 1976 by
Hacker Art Books,
New York, 1976.

Library of Congress Catalogue Card Number 73-88643
ISBN 0-87817-149-5

Printed in the United States of America.

Dedicated to

MY SISTER

Mary Benson Dorland

WHOSE STIMULATING INTEREST
AND UNTIRING ASSISTANCE HAVE
GREATLY HELPED ME IN
THE PREPARATION OF
THIS BOOK

✠

GEORGE WILLARD BENSON

CONTENTS

✠

ILLUSTRATIONS

✠

All of the crosses illustrated are from the collection of the author

FOREWORD

✠

HOW this book came to be written and why I have spent endless hours wandering in strange, out-of-the-way places in the old world, and in perusing numerous learned books and ponderous encyclopaedic articles, is solely due to a harmless hobby of mine.

I have been all my life a collector of things old and rare. A foolish waste of time and money most people think. But they do not know the joy and the lure of collecting. The collector has the true sportsman's spirit—the thrill, the confident anticipation and the uncertain realization of the fisherman. I longed to cast a line in strange, untried waters. I might never have done so had it not been that I once spent an idle year and more in Europe, traveling about with plenty of leisure and the acquisitive habits of a collector. And so I fell a victim to idleness and my inherent weakness.

Art, in its varied manifestations, always had a strong fascination for me. I might by preference have sought to collect paintings by the old masters, but as they are rather impossible to wrench from their museum moorings, I realized I must seek art treasures of another sort.

Artistic craftwork always greatly interested me. One day I saw a beautifully wrought antique cross upon the altar of an old church. Its charm of form, exquisite mastery of craftsmanship and the deep significance of its symbolism made an impressive appeal and I entered upon a new and absorbing adventure. I determined to become a collector of old crosses.

Modern crosses and even old ones of conventional forms and designs are comparatively easy to find, but the rarer, more unusual types are only to be found by long and diligent search. After many years of collecting, I have succeeded in securing a large number of old crosses and crucifixes, made of gold, silver, brass, bronze, copper, pewter, iron, wood, stone, pearl, mosaic, ivory, jet, tortoise shell and other

materials. They were found in Italy, Spain, France, Belgium, Switzerland, Germany, England, Hungary, Sicily, Russia, and other countries. They are of various kinds, from diminutive ornamental crosses, many of them set with gems or semi-precious stones, to larger Pendant, Altar, and Processional Crosses and Crucifixes. They date from the tenth century to the nineteenth century.

The infinite variety of design, ornamentation and symbolism affords a graphic and realistic impression of the variations through which the cross has passed in a thousand years of Christianity.

Some of the crosses are crude and inartistic, others delicate and beautiful in workmanship. The simple familiar cruciform design is in many crosses so adorned with an elaboration of fanciful decoration or symbolic emblems as to be scarcely recognized.

My collection of crosses is now in the Buffalo Historical Museum. It was deemed worthy of a place there on account of its historic and artistic value.

Making the collection I found to be one of the most absorbing interests of my life. It has stimulated my appreciation of artistic handicraft, and awakened a desire for knowledge in a hitherto unknown field of investigation. In the hope that others may also be interested in the history and symbolism of the cross this book was written.

It is not an exhaustive history, but records many authentic facts, legendary tales, curious customs and superstitions connected with the cross. Tells of notable events and personages that are interwoven in its history. Describes the various forms and uses of the cross, and the symbols that appear upon many crosses, and traces their similarity and significance to the symbolism found in religious paintings, mosaics and stained glass.

The history, the legends, the art and the symbolism with which the cross is intimately connected is the keynote of the book. The religious significance of the cross is suggested in a reverent spirit.

The Cross

ITS HISTORY
& SYMBOLISM

---✠---

THE INFLUENCE OF THE CROSS

I

THE cross for centuries past has been a symbol of vital influence in the worship and the lives of countless men and women.

No other symbol has had the widespread and important significance of the cross. It is the supreme emblem of Christianity, symbolic of sacrifice and redemption.

Four centuries and more ago, Savonarola, at the close of an impassioned appeal, held aloft a cross and cried, "Florence behold! This is the Lord of the universe. Wilt thou have Him for thy King?"

And with loud shouts the vast throng before him instantly responded, "Long live Christ our King!"

How came it about that the uplifting of a mere symbol could arouse the people to such an outburst of religious zeal and loyalty?

It was not merely the eloquence of Savonarola that stirred them—they refused to listen to him not long afterwards—but the symbol of their faith which he held high above his head. The cross was a vital force in their lives. It stood for the hope and belief they could not otherwise express. It was to them a sacred and impressive symbol.

This was at the end of the fifteenth century. A little more than four centuries later I stood in the same public square in Florence in which Savonarola was burned at the stake. Around about me were many of the same buildings that he last gazed upon. In one of them, the Palazzo Vecchio, I had just seen the little chapel where he spent his last night in prayer before a cross.

I wondered, as I watched the throng about me, some hurrying by, others idling and gossiping in the outdoor cafés, if they also could be stirred as were their forefathers, by the cross.

A useless question, I thought, impossible in this materialistic age and skeptical generation. A few days later I was convinced otherwise.

It was Corpus Christi day and I stood in the midst of thousands of people in front of the Duomo and saw a great religious procession come out of that beautiful cathedral, priests, acolytes and choristers—an innumerable host—bearing many banners, emblazoned with the emblem of the cross, and carrying hundreds of Processional Crosses of rare workmanship and beauty. Most of the sacred banners and crosses of the various churches of Florence, many of them centuries old, were to be seen in that most impressive procession, and while it passed, for nearly an hour, the vast throng of spectators stood with bared heads and in reverent silence.

All through the centuries the cross has been a symbol that has stirred the hearts and revived the faith of millions of believers.

Joan of Arc, bound to the stake, with the crackling

flames all about her, begged for a cross. A soldier fastened two small faggots of wood together and with this crude semblance of a cross in her hand and a prayer on her lips, Joan of Arc died. To her it was not only the emblem of her faith, but the assurance of her soul's salvation.

It is difficult for us in the midst of our modern and intensely material civilization to realize how vital and how widespread has been the influence of the cross all through the centuries.

In our own country at the beginning of its history, the cross had its place and influence.

About the same time that Savonarola uplifted the cross and made his appeal in old Florence, Columbus bore the cross into the New World. That was the custom of the age. All explorers carried the cross as well as a compass.

There is a painting in the Capitol at Washington of Columbus, with raised cross and unfurled banner, taking possession of the land he had discovered for God and king.

There is still to be seen beside the Fountain of Youth in St. Augustine, a cross of rough stones outlined in the earth which tradition claims was placed there in 1513 by Ponce de Leon to mark his landing place on the shores of Florida.

On the bank of the James River at Richmond, Virginia, is a great bronze cross that was erected on the spot where over three hundred years ago Captain John Smith had placed a wooden cross to mark the end of his journey of exploration up the river from Jamestown.

It was significant of the spirit of the age. The early dis-

coverers raised a cross wherever they went as a symbol that it was to be a Christian land.

But the cross was seldom seen after the first permanent settlers came to these shores. They were the Pilgrims, Puritans, Quakers, Dissenters and adventurers. Not a cross-bearer among them. In only a few scattered communities where there were followers of the Established Church of England and that of Rome was the cross to be found.

But in the old world, for centuries before and after the new world was discovered, the cross was almost everywhere to be seen. No great enterprise or crusade was undertaken that did not have the cross carried upon a staff or embroidered upon a banner.

Throughout all Christendom the cross appeared. It stood upon the altars of the churches, was carried in religious processions, and woven into the vestments of the priests, pictured on canvas and in stained glass, in frescos and mosaics fashioned with rich craftsmanship and hung upon the walls of cathedrals which were themselves built in the design of the cross. On every spire and many gables were crosses of iron and stone, and in the churchyards they marked the resting places of the dead. Everywhere were wayside shrines with crosses of wood and stone, Market Crosses of sculptured marble and Sanctuary Crosses to which men fled for refuge.

The Crusader's sword was cross-hilted and every Knight dedicated his sword upon the altar and wore a cross upon his breast, as he went forth upon a crusade.

The escutcheons of most ancient families bore it in

varied forms and it appeared frequently on the coins and medals of the realm. The crowns of kings and nobles were almost invariably surmounted by a cross.

The prevailing use and influence of this supreme symbol of Christianity is remarkable. The study of its origin, history, and symbolism is an investigation full of value and interest.

The cross is a symbol more universal in its use and more important in its significance than any other in the world.

II—LATIN CROSS

ANCIENT CROSSES

II

THE cross is the oldest symbol in the world. Centuries before the Christian era ancient crosses were in use as pagan emblems. They have been found carved in stone dating back to remote ages.

The origin of the cross is in the mists of antiquity. We do not know who first discovered fire, or who shaped the first pottery vase, or who built the first human habitation, nor do we know who first made a cross. It differed in shape and design as ancient peoples and civilizations differed. But in some form, all through the ages, the cross has existed and has had a vital significance and influence.

The ancients worshipped various gods whom they represented as adorned with crosses either on their persons or garments or carried in their hands.

The cross symbol was even more frequently used by itself; carved upon monuments, in bas-relief upon walls, made of pottery, wrought in bronze, silver and other metals.

Its use as a religious symbol seemed to have been almost a universal custom among ancient peoples.

The origin of the cross may have been due to the facility with which it could be outlined. From the dawn of antiquity when man first discovered that he could

draw shapes and forms upon flat stones, or could carve crude outlines upon them, evolved the symbol of the cross.

It is possible that it may not have been originally a religious emblem, or had any sacred significance. It is not improbable that it might have originated in some ancient game like the childish one of the three crosses and three circles in a row. These simple designs are easily drawn and have been strangely associated together all through the ages. The circle entwining the cross has become a familiar Christian emblem symbolizing eternal life, without beginning and without end. (Frontispiece.)

Many ancient crosses were not simple in design. They were overloaded with curious unintelligible decorations. Some of these embellishments are even grotesque. What was their original purpose and meaning is largely conjectural. The old proverb that "Antiquity is not always a mark of verity" is undoubtedly true of ancient crosses. They may have had a religious purpose or an entirely different significance. The undeniable truth is that crosses of many forms and designs that were made in remote times have been found nearly everywhere in the world. They are made even to this day by pagan peoples. Undoubtedly most of these crosses have a religious significance connected with some form of nature worship.

The simple equilateral cross probably was symbolic of space, the earth and sky. It is one of the earliest forms of ancient crosses and was traced on walls and carved in stone long before the birth of Christ.

This ancient cross, now known as the Greek Cross is today the symbol of the faith of millions of Christians.

THE PAGAN CROSS

III

PROBABLY the earliest known form of the cross was represented by the intersection of two lines at right angles. From it evolved the Swastika or Gammate Cross, which in its original form was in the shape of a curious capital Z. Its earliest significance was prosperity, its latest, for it is a symbol still in use, is good luck.

The Swastika Cross is of Sanskrit origin. Under somewhat varied forms it appeared among the ancient Aryan nations and early became a religious emblem. Its most familiar form was two arms intersected called pramatha and swastika. The early Aryans were fire worshippers and this was to them symbolic of two sticks with handles which rubbed together kindled the sacred fire. The Grecian myth of Prometheus who stole the fire of heaven from Zeus in a hollow staff and kindled the divine spark of life in man, possibly may have been derived therefrom. (Page 22).

The Swastika Cross differing in that its arms turn from left to right instead of right to left, appeared on early medallions of the Buddhists and is still used by some Hindu sects. It is known as the Good Omen.

The Swastika or Fylfot in its varied forms appeared as

a Good Fortune symbol in nearly all the early civilizations of Asia, Africa, Europe and America. It has been fre-quently found upon the pottery, jewelry, coins and monu-ments of the ancient peoples of India, Persia, China, Japan, Mexico and South America. Also on the pottery and baskets of the North American Indians and is still in use by them. The Swastika, all through the ages until the present time, has been a symbol of good fortune. Its use among modern nations is a curious survival of ancient paganism. Its latest and most notable use is as the Ger-man Nazi emblem.

There have been found ancient crosses, the handiwork of western Indian tribes of North America, with four arms of equal length with symbols of the four winds. The top of the cross is the cold north wind, represented by an arrow, the left arm the sharp east wind, represented by a star, the bottom the warm south wind portrayed by the sun, and the gentle west wind by a heart.

The Chinese had a saying that God fashioned the earth in the form of a cross. To represent that idea they placed the equilateral, or Greek Cross, within a square. The four ends of the cross indicating the four points of the com-pass.

Excavations in America and Mexico have brought forth crosses of many forms and designs made by the aborigines during the mound building period. Most of them are varied forms of the Swastika, also of the simple Greek Cross and the more ornate Maltese Cross.

It is curious and interesting to find these evidences of similar civilizations and religious beliefs existing in pre-

historic times in both the eastern and western worlds. These ancient crosses made by widely separated and alien peoples, similar in shapes and designs, have been found carved in stone and engraved on metals and shells and as decorations on pottery.

Almost from the beginning of recorded history there was another cross in frequent use known as the Tau Cross. In form it resembled the capital letter T. (Page 35). It has been called the cross of the Old Testament as it was known to the Jews. They may possibly have become familiar with it during their bondage to the Egyptians, as a cross much resembling the Tau Cross with a loop at the top appeared frequently in Egyptian hieroglyphs and carved on their ancient sepulchers and monuments. It was known as the Cross of Horus, an Egyptian god, and is usually held in the hand of a god, king, or priest. It was the symbol of life, and has been called the Key of Life.

In varied forms, the Tau Cross appeared throughout the ancient world. The Phoenicians adapted it to a crude representation of their goddess, Astarte—"she who gives life." The Greeks transformed and beautified the handled cross of the Egyptians into a representation of their God-dess of Life, somewhat similar in appearance to the figure of a woman with outstretched arms in the form of a cross.

Another form of cross known as the Greek Cross was used by various ancient races. It was simple in design, an upright line crossed at right angles by a horizontal line. (Page 25).

The primitive Greek Cross, in use a thousand and more years before the Christian era, was in form the same as the modern Christian Greek Cross. Recent excavations in Athens have unearthed ancient crosses similar in design to the familiar cross of the Greek Catholic Church in use at the present time. Its form is unchanged from the ancient Pagan Cross, except that it is usually embellished with ornamentation.

Another cross in use by some primitive peoples is the so-called St. Andrew's Cross which is merely the Greek Cross in another position. It resembles the capital letter X. How it came by its present name is due, doubtless to the fact that St. Andrew, the patron saint of Scotland, was martyred on a cross of this shape. (Page 39).

Saint Patrick, the patron saint of Ireland, has also been associated with it, but the reason is not very obvious, as he devoted his life to ridding Ireland of sin and snakes and died a natural death. However confusing these things may be historically, in art these saints are easily recognized. Saint Andrew has always his cross and Saint Patrick his Bishop's crook, with and without snakes.

Among the Romans and all Latin peoples another ancient cross was much in use. It resembled the Greek Cross with a long arm extending below. It was called originally the Latin Cross and is now known as the Christian Cross. (Page 15). From three ancient crosses, the Tau, the Greek, and the Latin, have evolved all the varied forms and designs of the Christian Cross.

The meaning and symbolism of the various Pagan Crosses, often vague and obscure, usually had reference to life in some of its manifestations, such as prosperity, abundance, fertility, and the blessings and desirable things pertaining to earthly existence. The sun, the source of all life, and the moon, stars, wind, water, and fire, also contributors to the needs of human life, were symbolized and invested with special significance.

III—SWASTIKA. ANCIENT PAGAN CROSS

THE CHRISTIAN CROSS

IV

HOWEVER mystifying and conflicting may be the meanings of the different Pagan Crosses, some of the symbolism that clusters around them has become interwoven into the symbolic thought connected with the Christian Cross.

The ancient Druids, who worshipped the sun, took as the symbol of their god a living tree, a stately oak, cutting off all its branches except two on opposite sides, forming thereby a giant cross.

The "accursed tree," as the early Christians designated the cross upon which Christ was crucified, a death of suffering and disgrace, has become the symbol of vicarious sacrifice and atonement. Christ Himself proclaimed that He must be lifted upon the Cross that He might draw all men to Him.

The meaning of the Christian Cross is clear and significant. It is the symbol of life eternal, of redemption and resurrection through faith. This is why it has been of real vital significance to millions of believers since the day upon which Christ suffered death upon a cross.

Christ's mission was to teach men, by word and deed the way of right living. His message was the revelation to

the world of God the Father. Until He came, men had thought of God as Jehovah, a just God without mercy. Christ proclaimed Him the Heavenly Father—a God of love and forgiveness. Other teachers have taught wisdom and morality; others have healed the sick and done deeds of charity. Christ, alone, brought to the knowledge of men that they were the sons of God, and pointed the way through faith and service to life eternal.

This revelation and all it meant, the Fatherhood of God and the Brotherhood of man, might have been unaccepted and forgotten by the world, had it not been that Christ made the supreme sacrifice.

The cross upon which He died was undoubtedly made of wood and in the shape of the familiar Latin Cross. This was the kind of gallows used by the Romans for the execution of criminals. No Roman citizen could be cruci-fied, but slaves and the condemned of other and despised races, were put to death, either upon a single stake driven through their bodies, or by being bound or nailed upon a cross.

The Hebrews usually stoned to death but occasionally used the cross of one form or another, from the time of Abraham. The famous gallows of Haman probably was a cross.

There would seem to be no reason to doubt that the cross upon which Christ was crucified was of the form of the so-called Christian Cross, the Cross of Calvary. It is so represented in nearly all of the paintings and mosaics of the crucifixion from the earliest beginnings of pictorial art. It probably was not as high as represented in most of

the paintings of the old masters. According to tradition it was fifteen feet high, but the customary height of crosses used for executions was not more than ten feet. It was part of the disgrace of the condemned that he should bear his cross to the place of execution. The crucifer, the cross bearer, was a term of reproach among the Romans. The condemned was often, but not always, scourged before his crucifixion. By the Jewish law this was limited to forty stripes but by the Roman law unlimited. With cruel vindictiveness the people demanded that Christ be stripped of His garments and scourged. And then upon His lacerated back bear His cross.

The Jews believed that whoever "hangeth upon a tree" was forever cursed. The cruel spirit of the mob condemned to an ignominious death the Man who had healed their sick and had brought to them the new message of love and service to others.

The Christian world today no longer thinks of the Cross as an instrument of execution, but always as a glorious symbol of Christ's sacrifice for all mankind.

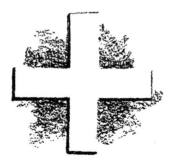

IV—GREEK CROSS

A LEGEND OF THE CROSS

V

IN ages long past legends and incredible tales were told about the cross as about most heroic and mythical characters and traditional events. It was the custom to invent imaginative narratives that in the telling grew even more imaginative and mythical.

A legend of the Cross of Calvary which has come down to us through the ages, seems so fantastic as to be almost incredible. It was probably told by father to son through generations of credulous believers, embellished with fanciful additions, until centuries later it crept into a printed book. It was recorded, also, in a quaint, mystical poem in the thirteenth century. One version of the legend runs somewhat like this.

Adam, when very old, some nine hundred and more years, racked with pain, remembered that he had been told that the leaves of the tree of life in the Garden of Eden had power to soothe pain. He thereupon persuaded Seth, his son, to procure from the angel-guard at the gate a slip from the tree, but Adam died before Seth returned. Thereupon Seth planted the slip at the head of his grave. It grew into a great tree, from one branch of which came the rod with which Moses smote the rock in the Wilder-

ness. Solomon had the tree hewn down to make a pillar for his temple. Strangely, it somehow never fitted anywhere, being either too short or too long, so he had it made into a foot-bridge over a brook.

When the Queen of Sheba came to Solomon, clad in all her fine raiment, she was supposed to walk over this foot-bridge, but her womanly intuition warned her not to do so. Another version of the legend records that no sooner had she set foot upon it than it disappeared in a bog and was lost to sight and knowledge of men. Centuries later it miraculously reappeared and from it was made the cross upon which Christ was crucified.

There is another legendary version that the angel on guard at the Garden of Eden refused the plea of Seth and gave him instead of a slip, three seeds of an apple picked from the tree of forbidden fruit, with the command to place them under Adam's tongue after his death. Seth did as he was told and from them grew three trees, a cedar, a cypress, and a pine. In course of time these three marvel-ously united and became one tree from which the Cross of Calvary was made.

This imaginative legend has connected with it so many famous biblical characters that it seems strange that it is so neglectful of others. Noah, certainly, could have used a few planks in the ark. However, the tale is perhaps suffi-ciently fanciful as it has come down to us.

Here ends the legend and history begins. History that is not without a few legendary touches.

CONSTANTINE AND THE CROSS

VI

IT almost seems incredible that the cross, the supreme symbol of Christianity, should not have come into use to any extent until nearly three hundred years after the death of Christ.

It would have appeared natural and logical, as crosses of various types had been for centuries in use as religious symbols, for the early Christians to have taken the Latin Cross as the emblem of their faith. The reason for their not adopting it until many generations of Christians had come and gone was probably due to several causes. One of these was that they were constantly persecuted and the necessity for concealment. The use of a cross as an emblem, made in the form of that upon which the founder of their religion had suffered martyrdom, would have marked them infallibly for persecution.

The very fact of the cross having been used for centuries for the crucifixion of criminals was a powerful reason for not using it as a religious emblem. To the early Christians it was a symbol of disgrace. They could not look upon it as an object of reverence. Death by crucifixion was the most shameful and ignominious that could be devised. That Christ should have been put to death, as were

debased and despised criminals, was bitterly humiliating to his followers. It was years before this deep rooted feeling could be overcome.

There are crudely carved crosses in the catacombs at Rome that are traditionally claimed to have been made by Christians of the first century. There is no proof when they were made, nor is there any historical record when the cross was first used as a Christian emblem.

Individual Christians may have occasionally erected a cross, but they were not in general use or probably even in the churches until the third century after the death of Christ.

In the year 312, the Roman Emperor, Constantine the Great, became an avowed Christian and undertook to convert his entire Empire to Christianity by imperial decree. In spite of his missionary zeal, Constantine was a questionable sort of Christian. His morals were not all that they should have been and he got rid of friends and foes, whenever he felt like doing so, by having them put to death. However, he was the first ruler in history to vigorously support the Christian faith. This was the result of a miraculous vision he had on the eve of a great victory over a powerful enemy. A luminous cross appeared at night in the heavens with the inscription beneath that by that sign should he conquer. He and his army were awe stricken. The next day he defeated Maxentius in a decisive battle and he thereafter had the Roman eagles supplanted by the Cross upon his banners and decreed its use throughout his kingdom.

The account of this event is related by Eusebius, the

Bishop of Caesarea, who asserted that it was communi-
cated to him by Constantine himself, who confirmed it
with an oath. The story is, that at the time of the great
battle Constantine was wavering between Christianity
and paganism. Knowing that Maxentius was seeking the
aid of magic and supernatural rites, he determined to
pray to the God of the Christians. While thus engaged he
saw at midnight a luminous cross in the heavens. Christ
appeared to him in a dream holding in His hand the same
symbol, admonishing him to place it upon his standards,
and promising him victory.

What Constantine saw, or believed he saw, was a
symbol already in use among the Christians often found
on their tombs. It was formed of the first two letters,
X P, of the Greek word for Christ, XPIETOE (Christos).
This form of the cross called the Labarum, Constantine
put upon his standards and banners and ordered placed
upon the altars of churches.

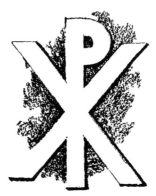

V—LABARUM, EARLY CHRISTIAN CROSS

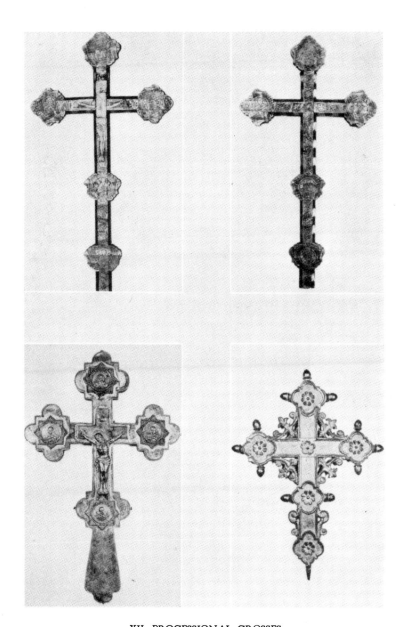

XII. PROCESSIONAL CROSSES

ITALIAN — *Pearl and Wood*
Christ and Saints
1600-1625

— Reverse
The Virgin and 4 Evangelists
1600-1625

HUNGARIAN — *Copper and Bronze*
God the Father — The Virgin — St. John
1725-1750

ITALIAN — *Gold on Wood*
Ornamented Design
1650-1675

FINDING THE CROSS

VII

THE Emperor Constantine, not satisfied with having established the first state religion, determined upon an attempt to discover the actual cross upon which Christ was crucified.

Being himself pretty well occupied at the time in conquering and Christianizing the pagans, he persuaded his mother to undertake a pilgrimage to Jerusalem for this purpose in the year 326. Although about eighty years of age, his mother, the Empress Helena, a very devout Christian, eagerly accepted the mission.

Aided by Saint Macarius, the Bishop of Jerusalem, she began a long and arduous search. Three centuries had passed and it was extremely difficult to locate the exact place of the crucifixion. It was somewhere outside the walls of Jerusalem, as crucifixions within the city were prohibited by law. It was the custom always to bury the cross after a crucifixion in a deep ditch and to cover it with stones and dirt.

In this instance great care had been taken to thoroughly conceal the place in which the cross was buried in order that no followers of the Christ should discover it. The knowledge of the place of concealment, however, had

been handed down in the families of certain Jews and from one of these descendants, an old man, curiously bearing the name of Judas, was the hiding place of the cross revealed. He refused to divulge the secret at first. Saint Helena had him cast into a pit to starve and after six days he agreed to lead her to Golgotha, the Hill of the Skull.

Over the spot, the Emperor Hadrian, two centuries earlier, had erected a temple to Venus. A heathen protest against the Christian faith. This temple Saint Helena ordered destroyed and an excavation made. Beneath the surface soil at a considerable depth, was discovered the tomb of Joseph of Arimathea in which Christ was buried and close by it the three crosses. Near them, but separated, the four nails and the superscription ordered made by Pilate.

Some modern writers have doubted the genuineness of the discovery but at the time it apparently was not questioned. The true cross had been found and the world rejoiced.

Along the coast of the Levant are the remains of ancient signal towers erected on prominent headlands ages ago. From these towers the glad tidings of the finding of the cross were flashed from Jerusalem to Byzantium. Tradition claims that by these flaming torches Saint Helena informed Constantine and a waiting world of credulous believers of her great discovery.

At first there seemed to be no way by which the true cross could be identified from the others until a dying woman was restored to health by touching it. This

miraculous, beneficent power it was supposed to always possess, which accounted for the tremendous demand thereafter among devout votaries for pieces of the true cross. A demand so great that, even though the pieces secured and placed in reliquary crosses and other sacred receptacles were mostly mere slivers of wood, the original cross would soon have completely disappeared had it not been for its reputed miraculous power of self multiplication, by which the supply always equalled the demand. All of which is legendary and traditional.

Saint Helena had the cross she found divided into three parts. One was left on the spot on which it was found, and a magnificent basilica was built to preserve it. This building was destroyed by the Saracens in the seventh century and the precious relic disappeared. Another portion was taken to Constantinople and in the thirteenth century was removed by Saint Louis to Paris where he built that gem of churches, Sainte Chapelle, to house the sacred relic. It is contained in a golden reliquary and is shown on holy days and festivals. The third portion was brought by Saint Helena to Constantine and by him deposited in the ancient church of Santa Croce in Rome, which he built especially to preserve it.

Considerable doubt has been cast upon this story of the finding of the true cross by modern writers, although historians and writers of the time of the discovery and for several centuries afterward apparently never doubted its authenticity. Bishop Macarius, it is claimed, was present when the cross was unearthed and there is no record that he ever doubted or denied the truth of the story or

questioned the location where the cross was discovered.

Constantine, according to tradition, erected on the spot where the cross was reputed to have stood and over the nearby tomb in which Christ was buried, a beautiful basilica which was destroyed by the Saracens and replaced in the twelfth century by the crusaders, which church was also destroyed. The present church of the Holy Sepulchre occupies the spot where once stood Constantine's basilica.

The doubts that have been cast upon the probability of this being the identical place of crucifixion were largely based upon the assumption that being within the walls of Jerusalem it could not be authentic. All crucifixions by the Jewish law were compelled to be without the city walls. However, comparatively recent excavations and measurements by archeologists have proved that the city boundaries were originally much smaller and that the wall in Christ's time was not where it is now, and that the disputed site was well outside the city wall, and may have been the identical place of crucifixion and burial as it has traditionally been claimed to be for centuries past.

Devout believers from far distant lands have come there to pray for ages past. Nearby are the graves of thousands of pilgrims who died lacking the strength or means to return to their far off homes, believing unquestioningly that they were on the hallowed spot where Saint Helena had discovered the true cross.

Some modern archeologists have doubted and denied that the Church of the Holy Sepulchre marks the identical spot of the crucifixion. That a rocky elevation of ground

near the city, and outside the present wall, called the Hill of the Skull, is the actual spot where Christ was crucified and that his body was placed in a tomb nearby called the Garden Tomb. It will probably always be a matter of doubt and conjecture which is the authentic place.

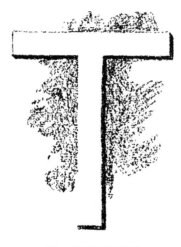

VI—TAU CROSS

RELICS OF THE CROSS

VIII

ALL through the ages there has been much dispute as to the kind of wood of which the cross was made. It has been variously claimed to have been made in part or wholly of cypress, cedar, palm, pine, box and olive wood and even of aspen and mistletoe, which at one time was a tree. Some modern writers are confident that it was made of oak, which is a tree often found in Palestine. There seems to be no authoritative or positive knowledge on the subject. As a matter of fact, very few, if any persons, for many generations past have actually seen any pieces of the cross. They are always securely concealed in their reliquaries.

There is a small piece, traditionally claimed to be of authentic genuineness, in Saint Peter's cathedral in Rome, which has been there since the sixteenth century. I was present, a few years ago, on one of the rare occasions when the ceremony of showing it occurred. It was just before Easter. A great multitude of worshippers thronged the cathedral and stood and knelt upon the marble floor, hushed and reverent, while high above in the dome, a priest unlocked the bronze door of a receptacle wherein were kept several sacred relics of the crucifixion, all en-

closed in elaborate golden reliquaries. One after another he lifted them up to view. Saint Veronica's handkerchief, a piece of the soldier's spear, and then for a brief moment he held aloft the reliquary that contained the small fragment of the cross. The reliquary was not opened.

Throughout the ages churches, monasteries and individuals all over Christendom have claimed to possess portions of the true cross. Most of them, however, are of doubtful authenticity. Erasmus believed that if all these fragments were collected there would be enough to build a ship. Dean Swift went even further, and declared that there would be enough to build sixteen large men-of-war. Even Calvin, the dogmatic reformer, who never doubted that Saint Helena had discovered the cross which had been borne by one man, asserted that all the relics claimed to be pieces of it could not be carried by less than three hundred men.

With all due respect to these most reputable and estimable writers, they must have been either misinformed or given to exaggeration. Modern investigation has proved that, contrary to general belief, there are comparatively few pieces in existence that are even claimed to be part of the true cross. None of them are large pieces and most of them mere slivers of wood. Of the few existing fragments of the cross that may possibly be considered as genuine, all of them pieced together would not make a cross of the dimensions of the Cross of Calvary, which probably was not more than ten feet high.

There is a legendary tale that Charlemagne wore upon his breast a fragment of the true cross, small enough to be

enclosed in an emerald, a sacred talisman which he believed made him victorious in many battles. Centuries later, Napoleon became its possessor and wore it during one or two of his battles, but had so much more faith in his star of destiny that he presented it to Hortense.

In the ancient church of Santa Croce in Rome is the largest alleged authentic piece of the cross. This church still stands on the Esquiline Hill, close to the Forum. Although restored three or four times, it is now in a somewhat ruinous condition. During one of these restorations in the fifteenth century was discovered a closed niche inscribed, "Titulus Crucis." When opened it was found to contain a lead coffer within which was a small piece of wood bearing a much obliterated part of the inscription "Jesus of Nazareth King of the Jews." This is believed to be part of the identical tablet which was fastened to the cross upon which Christ was crucified. It is less than seven inches wide and ten inches long. The wood is partly petrified and most difficult to determine from what kind of tree it came.

If the number of pieces claimed to be fragments of the true cross are beyond credence, this is also true of the number of nails used in the crucifixion of Christ. At most there could not have been more than four, but traditionally there are not less than thirty-two, scattered about in twenty-nine different places.

What became of the original four nails is also somewhat legendary. Tradition has it that one was cast into the Adriatic by Saint Helena to quell a violent storm. The others she gave to Constantine, one of which he had put

into his crown and another in his bridle. Of their final disposition it is believed that one is in Santa Croce in Rome, one in the cathedral at Treves and the third in the cathedral at Monza, just outside Milan. I journeyed there to see it. Whether it is genuine or not, it is evidently considered a most sacred relic and is securely contained in the recesses of an ornate altar.

It is concealed in the famous Iron Crown of Lombardy, with which all of its kings have been crowned from Charlemagne in 800 to Napoleon a thousand years later. This crown is kept in an elaborate reliquary within the altar which was opened with proper ceremony and I beheld dimly, through the cloud of incense, a plain gold crown set with a few precious stones. The Iron Crown seemed to be such only in name, but I finally discovered an iron band within the crown. This, it is claimed, is one of the nails from the true cross beaten into a narrow circular band. I was permitted to see it only for a brief moment and then amidst a thicker cloud of incense, the crown was returned to its niche and hidden from my profaning gaze.

VII—ST. ANDREW'S CROSS

THE EVOLUTION OF THE CROSS

IX

THE fact that the cross was not used by the early Christians as a symbol and did not come into general use until three centuries after the death of Christ, might have been because of His command to His followers not to worship any idol or graven image, but was probably due more to the fact that to them the cross was an instrument of execution and disgrace, and it was not possible for them to accept it as a symbol of sacrifice and redemption.

The necessity of caution to escape persecution was also a strong incentive. The caution that led them to conceal themselves and their dead in the catacombs would make them use a less obvious symbol of their faith.

The crudely incised crosses to be seen on the walls of the catacombs in Rome, which are claimed to have been carved in the first century, were probably made at a much later period.

The crude representations of a Fish, which have been frequently found on ancient walls and tombs, were probably made by primitive Christians. The Fish is known to have been a Christian symbol signifying baptism. The Greek word for fish is an anagram of the initial letters of

the following words: "Jesus Christ, Son of God, Savior."

Other symbols were used by the early Christians besides the Fish and the Cross itself. They were the Lamb and the Greek letters Alpha and Omega, the first and last letters of the Greek alphabet (signifying the beginning and the end). In an ancient tomb in Rome was found a metal cross bearing the inscription: "The Cross is life to me: Death, O enemy (the devil) to thee."

The Labarum of Constantine was a form of the cross principally used early in the fourth century. It combined the capital letter P with both the Greek and the Latin Cross. This was replaced by the simple Latin cross, which gradually became adorned and embellished by fanciful ornamentation and precious stones.

There are very few of the early Christian crosses still in existence. One of the oldest is in Saint Pudenziana in Rome. It dates from the fourth century. In the apse of the church is a beautiful mosaic, representing a seated figure of Christ surrounded by saints. Above His head is a large cross, suspended in the air, studded with gems.

Many of the earlier crosses are in mosaic, usually a part of elaborate frescos in mosaic. There is a fine example in a church in Ravenna in which Christ is standing holding a large cross with the archangels, Gabriel and Michael, on either side. This dates from the middle of the sixth century.

There is also in Ravenna a very beautiful cross, made a century earlier, in the chapel of an ancient church. The azure dome is set with golden stars, in the midst of which is a large golden cross.

All of these and many others of the numerous crosses that must have been made for ancient churches before the fifth century were all in the shape of the Latin cross. They were without symbols or the figure of the Christ upon them, but were elaborate in design and usually of gold and silver and adorned with jewels. Probably more of them would be in existence today, but they have been despoiled of their gems by vandals.

The jewels with which old crosses were adorned had particular significance. The ruby and the garnet represented the blood of Christ, the beryl, jade and other green stones signified regeneration and the pearl represented purity.

Every cross having a representation of the Christ upon it is called a crucifix.

It was not until the fifth century that any cross was made with the figure of the Christ upon it. The crucifix was unknown until that time. How it evolved and became embellished with various symbolic objects is extremely curious and interesting.

At first only the cross itself, unadorned, then the head of Christ without the body was painted either at the top or bottom of the cross, and a representation of the Sacrificial Lamb at the intersection of the arms. When these were replaced by the full figure of the Savior, it was merely incised or painted. It was not until the eighth century that the figure of the Christ became an actual bas-relief. At first He was always represented as alive, young and often beardless, with open eyes, his body untouched by nails or spear or crown of thorns, always with a loving

and compassionate expression. It was not until later, probably in the tenth century, that He was represented as dying or dead, with an expression of sorrow or suffering. The body was clothed in a sleeveless tunic from the neck to the knees. It was some time later, not until the fourteenth century, that the tunic was replaced with the loin cloth.

At first the Savior stood upon a base or pedestal or hung bound to the cross with feet uncrossed. Then later was nailed with four nails, and in the thirteenth century the feet were crossed and only three nails used, as is customary in crucifixes made at the present time. The beard, the pierced side, and the crown of thorns were later additions in the thirteenth and fourteenth centuries. At first the crown was a royal one, or merely a nimbus with golden rays. This was in keeping with the Latin inscription which Pilate ordered put upon the cross— "Iesus Nazarenus Rex Indaeorum"—(I N R I)—Jesus of Nazareth, King of the Jews. The I and J were interchangeable and the R stood for Rex. These four letters, I N R I, appear on a tablet on almost all crucifixes. On some crucifixes are affixed instead, the letters I H S which stand for the Latin, "Iesus Hominum Salvator"— Jesus the Savior of men.

The crown of thorns was put upon Christ's head as a symbol of ignominy and derision. It did not appear on early crucifixes.

The figure of the Savior when first represented as dead was very attenuated, and the way the figure hung and the droop of the head were indications of the age of

the crucifix, but by no means conclusive, as all the varieties of crucifixes described have been repeated all through the centuries, so none are in themselves proofs of the exact age.

There is an infinite variety both in designs and symbolic embellishment of the crucifixes of different ages and countries. Some of the symbols are difficult to interpret and some of the designs are quite inexplicable.

In an old church in Venice, Saint Patriarchale, is a very curious crucifix. The figure of the Christ is entirely draped in a long tunic and his face is black, producing an extraordinary effect. It is probably of Byzantine origin. There are certain African tribes who represent the devil as white, no doubt to prove the difference between themselves and the devil.

The most comprehensive knowledge of the varied forms of old crosses and crucifixes is to be obtained from ancient frescos and paintings of the crucifixion, as more of these are extant than the actual crosses made in the first thousand years of the Christian era.

Perhaps the oldest fresco of the crucifixion still existing is one I was privileged to see when in Rome. The fresco dates from the sixth century. It is on the wall of an ancient church built about that time. It was long since buried and forgotten, and another ancient church, Saint Clement, erected over it in the ninth century. About seventy-five years ago an excavation was made and the earlier church discovered, and beneath it a heathen temple, some centuries older, with a shrine and statue of some heathen god, and adjoining the temple a portion of the

house of Saint Clement, an early Christian, a friend of Saint Paul, who may have visited him in this house. On the wall of the sixth century church is the fresco, a simple plain cross with the figure of the Savior upon it. It is much faded. The colors are dim and soft, the drawing stiff and conventional. The Savior is clad in a tunic reaching from the loins to the knees. His arms are extended, His head, which droops, is surrounded by a cruciform nimbus. There is no sign of suffering depicted on His countenance. Below are His mother, with hands extended to her Son, and Saint John, looking up and pointing towards the Savior, who is represented as alive and standing upon a pedestal. No nails pierce His hands or uncrossed feet and there is no wound in His side.

All of the early representations of the crucifixion are similar to this one. There is in them no suggestion of death or suffering. No attempt was made at a historical representation of the crucifixion. Its spiritual significance only was emphasized. Painted generally upon gold backgrounds, with no suggestion of realistic details, the primitive paintings were primarily symbolic. This was also true of the early crucifixes. They were similar in details to the paintings and mosaics. Christ was represented not as suffering and dying but as triumphant over death. It was not until nearly the ninth century that His hands and feet were pierced with nails and He was represented as dying, a sacrifice for mankind.

There are two types in portraiture of the Christ, one is the Salvator type with nimbus, always having an expression of serenity, dignity or compassion. The other is the

Ecco Homo type with a crown of thorns, and an appear-
ance of suffering or death. This is the conventional form
of modern crucifixes. The idealized representation of the
crucified Christ was abandoned some centuries ago.

The crucifix is a form of the cross used largely by
Roman Catholics. The Latin Cross, plain or ornamented,
is the universal symbol of Christendom. An early orna-
mental development of the Latin Cross was the Floriated
Cross, its arms terminating in a flower or leaf design with
variations.

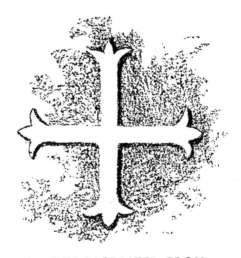

VIII—THE FLORIATED CROSS

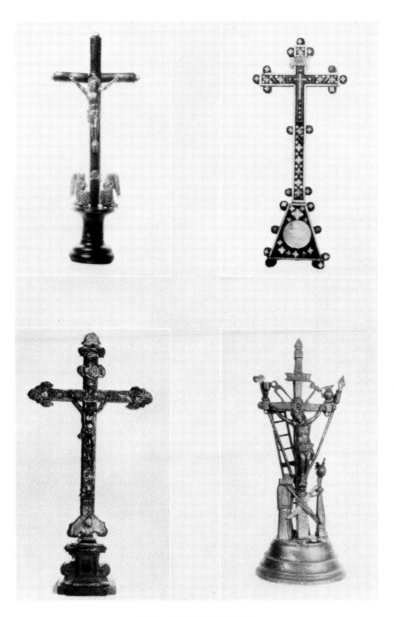

XIII. ALTAR CROSSES

GERMAN—*Brass and Wood*
with Adoring Angels
1800-1825

ITALIAN—*Pearl and Wood*
with Incised Cross
1775-1800

ITALIAN—*Bronze and Silver*
Ornate Design—Ebony Base
1650-1675

ITALIAN—*Brass*
with all the Symbols of the Crucifixion
1825-1850

WARS OF THE CROSS

X

LONG before the time when angels proclaimed, "Peace on earth, good will to men," in the days of David the Hebrew king, according to the Bible narrative, it was the custom in the springtime for the Israelites to go forth to war. There might not have been any good reason for doing so, as frequently is true in these later days, when war is ever threatening, but it was springtime, the season of the year to go to war. The Hebrews considered it somewhat of a religious duty. The war trumpets sounded from the hilltops and the people went forth to battle singing psalms and praying for the help of Jehovah. It seems almost incredible that so foolish a reason should have been the excuse for war. But all through the ages there have been many wars with no more justifiable reasons.

Even the emblem of the Prince of Peace, the Cross, has been the pretext for strife. The Crusades, of all the so-called religious wars, might have had some justification in that they were to recover Jerusalem and the cross from the unbelievers. The Holy Wars, men called them, but their record is filled with unholy acts and deeds.

The portion of the cross upon which Christ was crucified, that was left in Jerusalem, was guarded with reverent

care for nearly three centuries in the beautiful basilica built by Constantine. In the year 614, Chosroes II with a great Persian army laid siege and captured Jerusalem, slaughtered thousands of Christians, destroyed the basilica and carried away the remnant of the cross. That it was preserved was due to the persuasion of the Christian wife of that Saracen monarch. According to tradition, the cross remained in his possession for over thirteen years when he was defeated in a decisive battle on the plains of Nineveh by Heraclius, the Byzantine emperor. The cross was recovered and brought back to Jerusalem.

Mindful perhaps of the lowly Nazarene who had died upon it, Heraclius, in a spirit of humility, dismounted from his charger and with bared head and unshod feet, himself, bore the fragment of the cross to the place from which it had been taken.

Thirteen hundred years later, in the Great War, General Allenby, who has been called the last of the Crusaders, led a victorious campaign in Palestine. As the English troops drew near to the city, Allenby commanded that not a shot be fired within two miles of the walls of Jerusalem. When the victory was won, he entered the Holy City through a side gate on foot unostentatiously, without military pomp or parade.

Jerusalem has many times fallen before a conquering army. It surrendered to the Moslems soon after Heraclius brought back the cross. The Christians were permitted to retain it in their custody. For more than four centuries, pilgrims came from far countries to pray before this remnant of the cross and at the tomb in which Christ was

believed by thousands of people to have been buried.

It was the custom for these pilgrims to carry with them on their long pilgrimages a small metal cross known as the Cross Fitché (Page 56) which had a long, sharpened arm at the bottom by which it might easily be driven into the ground. As the pilgrims rested at night on the long journey to the Holy Land, this cross was set up by the roadside and beside it they would kneel and pray.

Not all of the great host of pilgrims were as devout as might be expected of devotees seeking a sacred shrine. The spirit of adventure, or the hope of gain, were motives more urgent with some of them than piety. Doubtless most pilgrims were sincere and truly devout, but tales are told of many who committed all kinds of sins and crimes on their pilgrimage to the Holy Land. It was a perilous journey. All the way from far distant lands to the Orient, the pilgrims were beset by enemies who beat and robbed them, and enslaved or killed a vast number. It was small wonder that some of the pilgrims paid back in like coin. Few of them ever returned to their homes. The long, weary pilgrimage, mostly on foot, beset with hardships and perils, if they escaped starvation, slavery or death, deterred many of them from attempting the homeward journey. The chance of obtaining riches and luxury in the Orient tempted others to tarry after their pilgrimage.

Among the many thousands who made the pilgrimage to Jerusalem was a man strangely destined to be one of the leaders of the first Crusade. He was Peter the Hermit, a hideously misshapen dwarf, the son of a Normandy nobleman. What little is known about him sounds like a

fanciful legend. He was illiterate but persuasively elo-
quent. Repulsive to look upon, he possessed a remarkable
power over both men and women. He won as his wife a
very lovely and talented lady of title, whose death a few
years afterwards caused him great unhappiness. He be-
came a hermit, living alone in the mountains a life of
sorrowful meditation. A monk visited him there and
persuaded him to make the pilgrimage to Jerusalem.

He soon gained remarkable influence over the pilgrims
of his company, claiming to have had a vision and a spe-
cial command to wrest the Holy City and the cross from
the iniquitous infidels. He so impressed Simeon the
Patriarch of Jerusalem, who was most desirous of having
it become a Christian city, that he entrusted Peter with a
letter to Pope Urban II, which exaggerated considerably
the terrible condition of the Christians living in Jerusalem
under infidel rule. Armed with this missive, Peter pleaded
with persuasive tongue the righteousness of his cause and
the Pope issued an appeal to all Christendom to go forth
upon a Crusade against the infidels. The appeal stirred
the Christian world. Such an enterprise, however, could
only be successful under the leadership of the knights and
men trained in warfare. It took time to organize and equip
an army.

Peter the Hermit, impatient at delay and covetous of
power, had more "visions" and proclaiming himself the
chosen leader started a Crusade of his own. He journeyed
throughout Italy, France and Germany arousing the peo-
ple by his fiery eloquence, denouncing all who would not
go to war and promising great rewards both in riches and

the forgiveness of sins to all who would enlist in the Holy War.

As tradition tells the tale, Peter the Hermit rode about upon an ass carrying before him a large cross. Whether he did or tramped about on foot, wherever he went great crowds followed him, persuaded by fear of eternal punishment or hope of earthly gain. Thousands of men, women and children in the spring of the year 1096, set forth under his leadership on the first Crusade. It was an unorganized, disorderly mob, mostly unarmed, that tramped through Germany and Hungary, plundering, persecuting and killing as they went on to Constantinople. Thousands died or were killed on the journey and only a remnant of the motley throng reached the city. A few months later this undisciplined band went forth and fought the Turks and were most of them slain. Only a very few of the followers of Peter the Hermit who had set forth upon that ill-fated Crusade survived to fight, long afterwards, before the walls of Jerusalem.

In the meantime the knights had rallied their followers and organized and equipped a great army that in the fall of 1096, under the leadership of Godfrey of Bouillon and other knights of France, Normandy and Flanders, reached Constantinople and set forth from there to conquer Jerusalem and to rescue the cross from the possession of the infidels. They were a long time doing it. They wandered deviously on the way, tarried frequently to capture and plunder various cities and towns and it was not until nearly three years later, in the summer of 1099 that a few of the Crusaders reached their destination.

After a siege of five weeks, Jerusalem was captured. The Jews, who lived there were burned alive in their synagogue and most of the infidels were massacred. The Crusaders slew men, women and children with merciless cruelty. Suddenly, in the midst of the awful carnage, a procession of chanting priests appeared, bearing the fragment of the cross for which the Crusaders had endured numerous hardships and had fought fierce conflicts. Almost in a moment the barbarous slaughter of innocent victims ceased and the bronzed warriors fell upon their knees in the blood-drenched streets. Jerusalem was won and the cross rescued from the possession of the infidels.

For nearly a hundred years the Christians were in possession of the Holy City and the sacred relic. Then a great army of Saracens led by Saladin lay siege to the city. The Christians went forth from its gates to battle with their enemies upon the plains of Galilee. They carried with them the revered fragment of the cross, believing that by some mysterious or miraculous power it would give them victory. They fought desperately and valorously but the Saracens were victorious. The Christian Knights and Templars rallied around the sacred relic and fought as brave men, fearlessly, but they fought and died in vain. Jerusalem fell into the hands of the Saracens and the cross was carried away by them. The gold and jeweled reliquary in which it was enclosed was rich plunder, but the fragment of wood within it was of no value or sacred significance to the unbelievers. What became of it no one knows. The Saracens carried it off and either concealed or destroyed it. There have been tradi-

tional tales of its reappearance at various times and places, but it never again passed into the possession of Christians and has long since completely disappeared.

For two hundred years the wars of the cross continued. There were seven great Crusades and numerous minor ones, all on one pretext or another designated Holy Wars.

Most of the knights of all Christendom were partici-pants in the Crusades. Some, no doubt, for mere adven-ture, others actuated by religious faith. Among the leaders of them famous in history and romance were Richard the Lion Hearted of England, Frederick Barbarossa of Ger-many and Louis IX, (Saint Louis) of France.

Most of the Crusades were more or less disastrous. It is claimed for them that the principal benefits that ac-crued were that they prevented the spread of Moham-medan rule in Europe, increased world trade and brought the culture and civilization of the East to the western world.

Of all the Crusades the most foolish and disastrous was the Children's Crusade in 1212. The failure to achieve the purposes planned, the wanton destruction of lives, and the crimes and sinful debaucheries that characterized most of the Crusades aroused a widespread feeling that the wrath of God must be appeased. It was believed that this could be done only by innocent children in a crusade against the unbelievers.

Monks went about promising safety and divine as-sistance, and over fifty thousand boys and girls set forth upon the ill-fated Crusade. The children from Germany, after great hardships, finally reached Genoa where the

promised miracle of a dry path through the sea failed to materialize. Few ever saw their homes again. Most of them died from disease or exposure and lack of food. The children from France, after many weary miles of travel, arrived at Marseilles, where they had been promised passage across the sea to the Holy Land. Two of the ships were lost in a storm and all aboard were drowned. The other ships safely reached Alexandria where the villainous traders who had promised to transport them, sold all the children who survived into slavery.

The Crusades were the wars of the cross against the crescent, the emblem of the Saracens. It was fitting and appropriate that the emblem of the Christians, the cross, should be conspicuously shown, not only upon the banners but upon the persons of those who fought its battles. The knights of the various nations wore upon their tunics and shields different colored crosses by which their nationality could be identified: a white cross for the English and a red cross for the French. The Flemish cross was green and the Italian blue. The cross of the Knights Templars was red and white. The form of most of them was the Greek cross as it conformed best in shape to either tunic or shield. The cross of the Scottish Knights was the St. Andrew's cross.

Not only were the knights distinguished by the colors of the crosses upon their tunics or shields but as they were clad in armor and their faces concealed by the visors of their helmets, they could not have been recognized by their followers except for the crosses borne or worn by them which were distinctively different in their designs.

This probably is one reason for the infinite variety of heraldic crosses.

It was a customary honor to carve upon the tomb of a knight his effigy. In many old cathedrals throughout Europe are to be seen these tombs. The knight lies recumbent upon his tomb in full armor with his sword clasped in his hands or beside him, and always with crossed legs to indicate he was no ordinary knight but a Crusader. If the brave knight within the tomb had gone on two Crusades his legs were twice crossed. I remember once seeing in Gloucester cathedral, the effigy of a valiant knight who must have spent the greater part of a long life going on Crusades, judging by the twisted and complicated crossing of his legs.

The time of the Crusades was a barbarous and superstitious age. In these doubting and skeptical times, it is difficult to understand the beliefs and motives of the men who lived in those far off days: sincere in their faith, believing much that is incredulous, but willing to suffer and die for what was to them a vital and righteous cause.

Many Crusaders doubtless were adventurers. It was a rude and barbaric age and men were savage and cruel and vindictive in their hatreds. But there were, without doubt, a great number of the Crusaders who were not adventurers, but were actuated by high and noble motives, willing to sacrifice even their lives for the cross they fought to recover.

These Crusaders sought no earthly gain: neither the plunder of rich cities nor territorial possessions. They were not soldiers of fortune or braggart adventurers. Be-

fore an altar every knight of old took the oath of knight-hood "to lead an honest life, to honor and protect women, to shield the weak, help the poor, defend the Christian faith, endure suffering and if need be death, for the sake of the Lord Jesus Christ." To the knights who took this vow and faithfully kept it, the cross upon their breasts and shields was an inspiring symbol.

IX—PILGRIM CROSS

MEDALS, COINS AND THE CROSS

XI

IF the Crusades, the wars for the cross, did not accomplish all that was hoped and believed would be accomplished, one thing seemingly trivial but of importance resulted. The cross, the symbol of sacrifice, became the emblem for valor and bravery. From the time of the Crusades until the last great war, decorations for chivalry and for distinguished service have been made in the form of the cross. Many of them that are not cross shaped have it embossed upon them. They are rewards either for bravery in war or noteworthy deeds in civil life, bestowed not by one but by nearly all of the Christian nations.

Probably the oldest of the orders of chivalry was that of the Knights of St. John of Jerusalem. Long before the first Crusade a hospital was established at Jerusalem by an order of Italian monks known as the Hospitallers of St. John. They cared for the numerous sick pilgrims to the Holy City. Their kind ministrations to them and to the sick and wounded Crusaders who came later, endeared them to all whom they helped. They received gifts of money and lands and their numbers increased greatly. Many knights and their followers, who had come from

various countries to fight the Moslems, joined the order.

Early in the twelfth century, the alien groups were organized into an order both religious and military, and for centuries this strangely united brotherhood cared for the sick and the poor and whenever needed took up arms in defense of Christianity. There were three classes within the order, the knights, who were men of noble or gentle blood, the clergy or chaplains, and the serving brethren, those not of rank, who assisted as helpers in the hospitals or as esquires to the knights. At first they all wore black robes with cowls and a cross of white linen with eight points upon the left breast. Later, the knights were distinguished from the others by a white cross upon a red ground. The fame of their bravery, for they fought fearlessly in every battle against the infidels, attracted to their ranks numerous representatives of some of the noblest families from nearly every country in Europe. They captured and occupied at various times the islands of Cyprus, Rhodes and Malta.

The insignia of the Knights of St. John of Jerusalem, bestowed for valor or distinguished service, was the Maltese Cross. It is still in use. The British lion is between the arms of the cross on the insignia of the English Knights of St. John of Jerusalem, and the Prussian eagles between the ornate arms of the Maltese Cross on that of the German Knights of St. John. The decorations of chivalry of other nations are not only the Maltese but other forms of the cross. The Latin, the Greek, the Cross Patté, the Floriated Cross and that of St. Andrew have all been used as significant and appropriate for dis-

tinguished service medals by England, France, Germany, Italy, Spain, Holland and many smaller nations.

The two forms of the cross most frequently used have been the Maltese Cross (Page 67) with arms of equal length terminating in notched or indented points, and the Cross Patté (Page 81) of the same shape with arms broadfooted.

On other medals, round or oval in shape, crosses appear, either engraved or embossed upon them.

The Order of Christ of Portugal has upon it an enamelled Latin Cross. The Order of the Redeemer of Greece is the Patté, the Broadfooted or Spatulated cross, surrounded by a wreath with the head of Christ in the center.

The Order of St. Andrew of Russia has the Russian double eagle beautifully enamelled and St. Andrew impaled upon his cross. The patron saint of Scotland seems strangely out of place on a Russian insignia.

The papal medal, awarded to the Irish Brigade that fought in the Italian wars for independence, is a circle enclosing the cross with St. Peter crucified upside down. These two martyred apostles, believing themselves unworthy, refused to be crucified as was their Lord. St. Andrew died upon an X shaped cross with arms and legs widely extended. St. Peter was hung upon a cross, head down and feet stretched upward.

The famous war medal of England, the Victoria Cross, is in the shape of the Broadfooted Cross. In the center is the royal crown surmounted by a lion. It was first bestowed upon the heroes of the Crimean War and is still

considered a trophy of great honor and distinction.

The Iron Cross of Prussia, in the form of the Broad-footed Cross has been given both to German officers and men for valorous deeds in war since 1813.

Many of the Italian decorations for valor are in the shape of the Greek Cross and the insignia of various other countries are either in this or other forms of the cross or have it embossed upon them.

The latest distinguished service cross of the United States is of bronze in the shape of the Greek Cross with the American eagle upon it. This cross is given for bravery in action either to an officer or a private soldier.

In Russia, under the soviet rule, all distinguished service medals have been abolished except the ancient Cross of St. George of Russia, which is now bestowed upon any person deserving honor. St. George, the patron saint of monarchial England seems curiously alien to Soviet Russia.

At least seventy-five per cent of all orders of chivalry and decorations for bravery and distinguished service are either in the form of the cross or have the cross upon them. For many years past and probably for many years to come the medals and badges of nearly all Masonic, Knights Templar and fraternal organizations are of some cross design or have the cross embossed upon them.

In ancient times, crests and coats-of-arms often bore the cross in some form. It still appears upon the national coat-of-arms of Italy, Greece, Denmark, Portugal, Switzerland, Sweden and Norway.

On the crests of heraldry of ancient families appear a great variety of distinct types of crosses. On the armorial

bearings of the knights of old, the Crusades in which they fought were indicated by one, two or three crosses.

From the beginning of the Christian era until our own time, the cross symbol has appeared upon an absolutely incalculable number of medals, crests and coins, a conspicuous proof that the cross is an emblem more universal in use than any other in the world.

For centuries before the Christian era the cross appeared occasionally on coins, as it did on pottery and monuments. This, the earliest of symbols, had various meanings and diverse significance until it finally became the supreme emblem of Christianity.

As such it first appeared in the fourth century upon the coins of Constantine the Great in the form of the Labarum. Other forms and shapes of the cross appeared on silver and bronze coins from the fourth to the tenth centuries issued by order of various Roman emperors. It was usually held in the hand of some person. A bronze coin of Theodosius in the fourth century had upon it two seated figures, one bearing a scroll and the other the Latin Cross, which is supposed to have been the first representation of the cross as a sceptre.

A coin issued by Galla Placidia in the fifth century has an angel holding a cross, perhaps intended as a suggestion to a heedless and profligate generation of the good uses to which money might be put.

The Emperor Justinian in the sixth century had upon his coins the Cross Flory, the earliest variant of the sim-

ple unadorned cross, and on later coins appeared the Greek Cross. Justinian, it is claimed, was one of the first to believe in the idea that the cross was symbolic of eternal life and the first monarch to surmount his crown with a cross and to build a church in cruciform shape.

A later emperor, Phocas, in the seventh century, was first to have upon his coins the cross surmounting the orb, signifying the supremacy of the spiritual over the temporal world.

I have a number of ancient Roman and Byzantine coins with crosses upon them, dating from the fifth to the eleventh centuries. One of these bears the portrait of a Roman emperor with a most supercilious, self-satisfied expression on his face, holding an orb with the Latin Cross in his right hand. Over his left shoulder is a Greek Cross.

Another ancient coin of mine bears the portrait probably of a Byzantine ruler with a serene, oriental countenance and elaborate headgear and garments. He holds the Latin Cross and on the reverse appears the Greek Cross.

The cross appeared in one form or another upon coins for many centuries, not only upon Roman coinage but upon that of other nations. In England coins bearing the cross first appeared in the reign of Egbert about the middle of the seventh century and continued to be used for a thousand years until the time of James I in the seventeenth century. On the early English copper coins the Greek Cross was frequently stamped and so deeply impressed that they could easily be broken into halves and quarters. These coins were called Crosses and are so men-

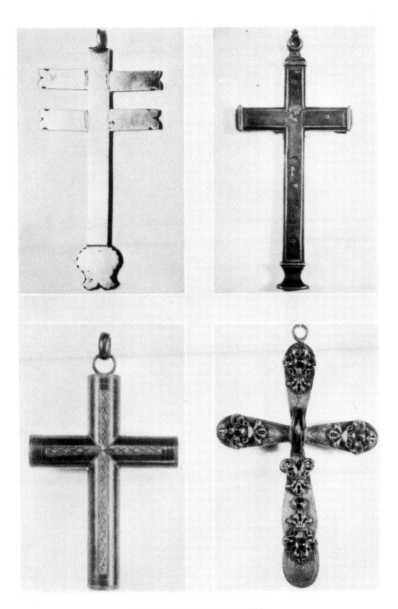

XIV. PECTORAL CROSSES

MEXICAN—*Silver*
Archbishop's Cross
1800-1825

SPANISH—*Brass and Steel Inlay*
Bishop's Cross
1800-1825

FRENCH—*Tortoise Shell and Gold*
Bishop's Cross
1675-1700

FRENCH—*Gold and Amethysts*
Bishop's Cross
1825-1850

tioned in literature. There is an old tale that the Scotch when plighting their troth would break "a saxpence" and divide it between the lad and his lassie. A man without money in his pocket was designated as a man with no cross to carry. Shakespeare makes Touchstone say: "I had rather bear with you than bear you. Yet I should bear no cross if I did bear you, for I think you have no money in your purse."

Ancient French coins had the cross upon them and upon the reverse a column, called a pile. The old custom, which has come down to our times of "pitch and toss," flipping a coin to decide a question or a controversy, is referred to by Shadwell, who must have been a crabby old soul. Writing of the lottery of marriage he said, "Marriage is worse than cross I win, pile you lose."

It was perhaps a fitting custom that for centuries papal coins were issued with the cross in various forms upon them. I have a silver coin of Clement XIV, dated 1777, having upon one side St. Peter and St. Paul with their ever present symbols of a key and a sword, and on the other side the papal coat-of-arms with a cross in the center.

An ancient writer, Gretser, somewhat satirically wrote: "Truly it pleased the rulers of Christian nations to place on money the most sacred sign of the cross that those who loved not the cross on account of Christ might love it for the sake of the coin."

For many centuries past there have been made a great variety and number of religious medals. They commemorated important events or were in honor of various

saints and also ecclesiastical personages of importance.

I have collected many of these interesting medals. They are of silver, bronze, copper and brass, and are usually round or oval in shape. It seems strange that not one of those I possess is made in the form of a cross. Comparatively few of them have the cross upon them and rarely the crucifix, although they are all Catholic medals.

One of them issued about the middle of the seventeenth century represents St. Francis of Assisi kneeling and receiving the stigmata as he beholds the crucified Christ. On the other side of the medal is the Virgin standing above the moon and clouds signifying that she is the Queen of Heaven.

On another of about the same century, the Virgin is holding the infant Christ, attended by angels and on the reverse is a dying saint surrounded by other saints, one of whom holds up a crucifix.

A curious sixteenth century bronze medal has the crucified Christ upon a cross, the arms of which are themselves cross shaped, surrounded by a circle of rays of glory. On the reverse are two hearts: Christ's has a cross above it and the Virgin's is pierced with a sword and above them both is the crown of victory.

On another medal of the 18th century bearing a representation of the crucifixion, Christ is upon a Floriated cross attended by angels bearing torches.

Upon many of my religious medals appear the simple Latin Cross and upon others crosses of various kinds more or less ornate. Some of them have portraits of early popes. It has been the custom for hundreds of years to

issue a medal upon the ascension of a pope to the ponti-
fical throne bearing his portrait. On only a few of these
the cross appears. Other papal medals are issued for com-
memorative purposes, either for a victory in war or some
notable or praiseworthy event.

I have two or three medals of different dates and de-
signs having upon them the representation of an open
door. It has long been the custom to close and seal up one
of the main entrance doors of St. Peter's cathedral in
Rome, which remains closed for twenty-five years, when
it is opened with great ceremony. On that occasion a
medal is struck bearing a representation of the open door
in the center of which is a cross, with the ruling pope
standing before the door, surrounded by prelates holding
crosses.

My experiences in finding these religious medals were
interesting. The medals turned up in most unexpected
places, and the quest for them was always alluring. I
found them in little curio shops in unfrequented streets,
at the rag markets in the public squares, and on peddlars
push carts in busy thoroughfares in the old cities of Italy,
Spain and France.

One day, having spent several hours among the art
treasures of the Uffizi, a much frequented haunt of mine
during a long stay in Florence, I strolled down the busy,
narrow street leading to the Ponte Vecchio and by chance
met an old friend from my home town, that beloved and
well-known man Bishop Charles Brent. He was accom-
panied by the rector of the English Episcopal Church of
Florence, whose guest he was, and I was invited to go

with them to his home and had a most enjoyable experi-
ence. Bishop Brent showed me a curious, ancient cross
belonging to him that had been lost in the River Tiber
for hundreds of years. The rector also showed me a num-
ber of old religious paintings he had collected. On my
collecting habits being revealed, he confided to me that he
had obtained many of his paintings from an antique dealer
who had no shop but displayed his wares on a push cart
and the cobblestones of an unfrequented piazza.

I visited the place the next day, hoping to find a valuable
"old master" for the traditional song. There was not one
among the unattractive lot of modern pot boilers and
dingy old canvases, but my quest was not in vain. Hid-
den among a lot of uninteresting junk on a rickety push
cart was a little bronze pendant Italian crucifix, made
probably about the last of the 18th century with some
interesting symbols upon it. Above the tablet I N R I
is the Dove with wings outstretched, the symbol of the
Holy Spirit and at the foot of the cross, the Lamb of
Sacrifice upon an altar. On the arms are the heads of
Mary the mother of Christ and St. John, his beloved
disciple. (Page 118).

I succeeded, after much persuasion, in securing this
cross and a beautiful old rosary with sparkling garnet
beads, and two or three religious medals. The most inter-
esting one was a large silver medal dated 1684, bearing a
profile portrait of Pope Innocent XI, who looked for all
the world like one of the proud and cruel Medici. It was
a commendatory medal such as were occasionally given
by popes for deeds of valor or virtue. This one was for a

victory over the infidels, probably the Turks, who seemed to be always fighting the Christians.

With these treasured relics in my pocket I wandered through the historic streets of the old city, by palaces and churches wherein were rare paintings and statues, the handiwork of the famous artists and sculptors of the golden age of art, reminders of those far-off days of the Medici when Florence was great and famous.

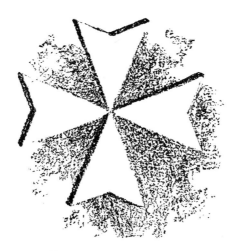

X—MALTESE CROSS

FORMS OF THE CROSS

XII

THERE are only three or four cross shapes or forms, but many modifications of them, as in music there are only a few tones but infinite variety of melody. Two distinctive types of the cross have predominated for many centuries. The Greek Cross in the Eastern world and the Latin Cross in the Western are in universal use as the symbols of Christianity.

These crosses also have been used for other purposes beyond their original use as purely religious emblems. They appeared on ancient coins and surmounted the crowns of sovereigns and nobles. In heraldry the cross in varied, elaborate designs was a familiar motif. Distinguished service medals and masonic badges are often made in the shape of a cross. It has been worn as a decoration upon the breast by valorous men, and for ornament by fair women. For centuries past the cross, in various forms, has been woven in Oriental rugs. And for hundreds of years the cross has been used as a memorial to commemorate the deeds of the great and the memory of the humble who are dead. Boundary Crosses have been used as markers for church lands, Market Crosses for pulpits and rostrums, from which the throng could be addressed,

and Wayside Crosses, beside which the traveler could rest and pray.

But principally the cross has found its true place in churches and cathedrals upon the altars, walls, spires and pinnacles, and in mosaics and stained glass. The Greek Cross, particularly, has been used decoratively in both Catholic and Protestant churches throughout the entire Christian world. It appears upon the robes and crosiers of the clergy and upon altars, banners, and vestments.

The Latin Cross, in both its simple, unadorned form and more elaborate and ornamental designs, has increased in general use enormously within the past hundred years. Formerly, it was rarely seen in many Protestant churches. It is now accepted quite generally and used as a symbol most fitting and appropriate for a place in all Christian churches as a sacred reminder of the Founder of their religious faith.

The Latin Cross has been variously designated as the Passion Cross, the Cross of Calvary and the Holy Rood.

In cathedrals the Rood screen separates the nave from the chancel, the congregation from the priests. It is usually made of iron or some other metal, stone or marble, or carved and painted wood. The Rood screen is sur-mounted by a large cross, usually made of wood painted or gilded and richly carved and floriated in design.

When there is no Rood screen, a large cross suspended on the wall is called the Rood.

In architecture the cross has had an important place, not merely in adorning the spires, gables and turrets of ecclesiastical edifices, but cathedrals, in the design of the

nave, the transepts and the choir, conform in shape to the Latin Cross and occasionally to the Greek Cross.

For centuries past, since the middle of the sixth century, the spires of the old cathedrals and churches in England and on the continent of Europe have been surmounted by crosses. Gable Crosses also of beautiful and varied designs adorn their exteriors and within them are often to be seen an endless variety of Sepulchral Crosses carved or incised upon marble slabs or tombs. Outside in the quiet churchyards are many Monumental Crosses erected to the memory of the beloved ones who rest beneath.

On some of these old churches is an architectural embellishment known as the Cross of the Resurrection. It is used, however, much more frequently as the staff for a religious banner. It is in the design of a lance terminating in a cross instead of a pike.

The crosslet, in the form of the Greek Cross, with its extremities intersected so as to make five crosses in all, has been much used in ecclesiastical architecture, also in other ornamentation and as a heraldic design, and occasionally as a decorative cross.

In heraldry no symbol is so important as the cross. There are over fifty distinct designs, mostly variations of the Greek Cross. The most important of these are the Crosses Floré and Treflè and others of the Greek Cross shape that terminate in threefold clusters signifying the Trinity. The Floré or Floriated Cross (Page 46) is the most familiar of these crosses. The Patté, or Broadfooted Cross, is another familiar design. It symbolizes the open

wings of a bird, suggestive of the protective power of the cross (Page 81). The Maltese Cross is a design even more familiar. It resembles the Cross Patté, with indented arms forming eight points, symbolizing eight Beatitudes. It is the Cross of the Knights Templars and the Knights of St. John of Jerusalem. (Page 67).

All of these Heraldic Crosses were used on the banners, shields and crests of the Crusaders and have ever since been used in ecclesiastical art and architecture.

The sword of the knight of old was consecrated upon an altar before he went forth upon a Crusade. Its hilt was fashioned in the form of a cross and it was held up before him as a sacred symbol if he died upon the battlefield.

The Cross of Lorraine, a double barred cross with a short arm above a longer one was adopted by Godfrey of Lorraine, a leader of one of the first Crusades, as his standard when he was chosen ruler of Jerusalem. It was a familiar symbol to the Crusaders for two centuries. A few years ago it was adopted as the symbol of the modern crusade against tuberculosis and every year this cross appears upon the Christmas seals.

The cross upon a banner has been in constant use all through the centuries. Not only upon the banners of the Crusaders in the Holy Wars but in many unholy ones without righteous cause or justification. It also was borne upon the banners of discoverers and conquerors of new lands, an emblem that it was the banner of a Christian nation. Columbus carried with him on his first voyage of discovery not only the Spanish standard but a white banner having upon it a green cross.

The banner of Venice bears the Lion of St. Mark holding in his right paw a cross. In time of war the Lion holds a sword in place of a cross.

A banner, bearing upon it a cross, which later became the banner of England, was given by Pope Alexander II to William the Conqueror. He fastened it to the masthead of his ship and with this banner invaded England in that memorable year 1066.

The Banner of Saint George, a red cross on a white field, has long been the distinctive banner of England. Her Union Jack is a combination of the crosses of Saint George of England, Saint Andrew of Scotland, and Saint Patrick of Ireland.

The original banner or standard of the New England colonies was the Banner of Saint George, but it was a stumbling block to their Puritan consciences and John Endicott publicly cut out the offending red cross with his sword. This was in 1634, but the Banner of Saint George of England was in use generally in the colonies until the Revolution.

Church banners with a representation of the cross, either embroidered or painted upon them, have been constantly used for centuries. They are carried always in religious processions.

The use of banners in Protestant churches in this country has grown in popularity greatly within the past generation. A somewhat uniform design, the Greek Cross on a blue and white field, has been adopted by various Protestant denominations for a church banner.

The cross itself, known as the Processional Cross,

made usually of gold, silver, bronze or wood, has been borne upon a staff in processions in churches and upon the streets for centuries past. From the time of the crusades and long after, it was carried before kings and heroes and distinguished personages when they entered or departed from ancient towns.

Prester John, a legendary king and priest of the Christian faith, who lived in the middle ages, claimed sovereignty over a vast territory and numerous inhabitants. According to tradition, he made demands of kings and popes for increased power and lands—not entirely an obsolete custom—and invaded Europe with a vast army and fourteen golden and bejeweled crosses. Each cross, according to the legendary account, was followed by ten thousand horsemen and one hundred thousand foot soldiers, a warlike demonstration that must have been terrifying if true. An army in those far-off days of over a million and a half would seem to be somewhat overestimated. In time of peace Prester John's army carried only a single, unadorned cross of wood.

ECCLESIASTICAL CROSSES

XIII

CERTAIN crosses are pre-eminently associated with the church and its worship. These are the Processional Cross, the Altar Cross, the Pectoral Cross and the Crucifix.

It is curious and almost unbelievable how rarely the cross was found in the early Christian churches. Constantine decreed that crosses be placed upon the altars of basilicas and erected in the streets of cities within his realm. Apparently they did not meet with popular favor and it was long after his death before the cross became a familiar object upon the altars and the walls of churches, or in the public squares and market places.

It required an ecclesiastical decree of the Council of Tours in the year 567 to establish its use in the sanctuary. That mandate directed that "the elements of the Eucharist should be kept under the figure of the cross upon the altar" and furthermore forbade the celebration of the ordinance of the Lord's supper without the presence of a cross upon the table.

Even this decree did not apparently create a desire for many Altar Crosses. There were comparatively few crosses or crucifixes in churches until the fifteenth cen-

tury. There are only a very few made prior to that time still in existence. The paintings of the Italian painters, from the early Primitives to those of the Renaissance, show altars with few church ornaments and with only one or two, and in some instances, no cross at all upon them.

The golden age of art produced not only paintings and sculpture of a superior quality, but developed a crafts' manship that produced crosses and crucifixes of rare beauty and exquisite art.

The early Christians, following the teachings and the precepts of Christ, were very simple in their worship and religious forms and observances. They were without churches, ritual or ceremonies. The reaction was most remarkable and revolutionary. Magnificent basilicas, gorgeous priestly robes and ceremonial services took the place of simplicity of personal service and worship.

The altars were adorned with crosses of precious metals, ornamented with rare jewels. Elaborate Rood Crosses, carved with symbols and surrounded by the figures of saints, surmounted the Rood screens. Crucifixes and Pendant Crosses of beautiful designs and artistic craftsmanship hung upon the walls. Banners and frescos and architectural carvings pictured the cross on every side. Religious processions of gorgeous pomp and pag' eantry marched through the aisles of the churches and the streets of cities, always led by a cross-bearer or crucifer, carrying a Processional Cross.

The Processional Cross is usually of metal, very hand' some, and of a floriated design, sometimes bearing sym'

bols upon the arms or the Lamb of Sacrifice on the reverse side. The Processional Cross has been in use from about the same time as the Altar Cross. It is a reminder of the cross borne by the Savior on the day of His crucifixion. (Page 30).

The Altar Cross stands upon a base or pedestal in the center of the altar, the position of supreme importance. It is either simple in design and inexpensive, or most elaborate and valuable, according to the resources of the worshippers.

The less pretentious Altar Crosses are made of wood, brass, bronze, copper and pewter. The more valuable ones are of gold, silver, crystal, ivory, etched metals and carved wood, gilded or inlaid with pearl and tortoise shell, in design both simple and ornate, many of them hand-wrought with consummate skill and artistry and ornamented with precious gems. (Pages 46 and 166).

The Pectoral Cross, frequently very ornate and jeweled, is the cross worn upon the person, by high dignitaries of the church, and, also, by sovereigns and persons of exalted rank.

The earliest known cross of imperial character, a beautiful jeweled one, was found in the tomb of Queen Dagmar of Denmark, who died in 1213.

The earliest known cross worn by a prelate dates back to the year 461, when it is claimed Pope Hilarius wore a Pectoral Cross, and they have been worn more or less by prelates ever since. Pope Leo II is reputed to have possessed a gold reliquary cross containing a piece of the true cross. All of these Pectoral Crosses were without distinc-

tive form. They were more or less ornamented and jeweled as appealed to the individual taste of the wearer. It was not until the fourteenth century that a cross of a prescribed form and design came into use to be worn only by cardinals and archbishops.

This was known as the Patriarchal Cross. In form it is the simple Latin Cross with a short arm above the inter-secting arm. It is supposed to have originated from the tablet which Pilate ordered placed above the head of the crucified Christ. (Page 62).

The Patriarchal Cross, sometimes known as the Lor-raine or Jerusalem Cross, was originally adopted as his cross by Godfrey de Bouillon, Duke of Lorraine, who was chosen the first King of Jerusalem by the crusaders.

Another form of the Patriarchal or Lorraine Cross has three horizontal arms instead of two. This triple cross belongs exclusively to the pope and is worn only by him and carried before him in processions.

The cross worn by a bishop is a plain or ornamented or jeweled Latin Cross and is worn as the symbol of his authority as bishop. (Page 62).

There is still another cross with two horizontal arms that is not a Patriarchal Cross. It is of Spanish origin. Centuries ago by a special papal dispensation, in gratitude for the cessation of a plague, crosses of this kind were permitted to be made in Spain only. Since then a great many of these double arm crosses and crucifixes have been made, in a variety of designs, and of different materials, principally bronze and silver, embellished with symbols and ornamentation. Many of them are Reliquary Crosses

holding sacred relics and are of various sizes, designed to wear upon the person, or hang upon the walls of chapels and homes. (Page 94).

Crucifixes are to be seen in all Roman Catholic churches and also in a few Protestant ones. It is a singular fact that it took an ecclesiastical decree to bring this about. In the Quinsexton Council, known as that of Turllo, in 691, it was decreed "that the representation of Christ, who takes away the sin of the world, be henceforth set up and painted in place of the ancient Lamb."

This decree, no doubt, was obeyed, but it is undoubtedly true that crucifixes were uncommon for many years thereafter and their use was not widespread either in churches or homes for several centuries after it was promulgated.

All forms of art were at a standstill during the dark ages which accounts probably for the scarcity of all kinds of crosses made prior to the fourteenth century.

Some old crucifixes are still to be found, with the Lamb on the reverse side or at the foot of the cross. The Greek Catholic church has never used the crucifix. A Byzantine Council in 753 forbade the use of all images, and since then bas-reliefs and statues have been banished, although pictures and mosaics of the crucifixion and Russian icons representing it have been permitted. Although rare, occasionally an old Russian crucifix is to be found. I secured one in France from a Russian refugee, a cultured lady of the aristocracy, who brought it from Russia with a number of icons and other art treasures. It dates from the seventeenth century and is made of brass and of a very

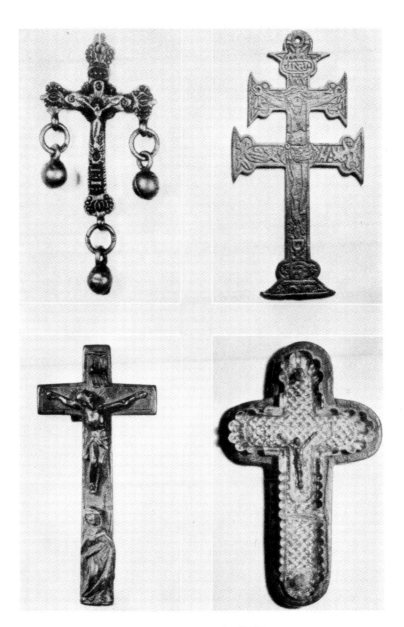

XV. PENDANT CROSSES

Russian—*Silver*
with Pendant Bells
1750-1775
Swiss—*Carved Wood*
Crucified Christ—The Virgin Below
1625-1650

Spanish—*Brass*
Elaborate Incised Design
1750-1775
French—*Wood and Crystal*
The Christ Figure in Bronze
1800-1825

curious design. (Page 158). It is much worn, especially the figure of Christ, which is extremely attenuated. Above His head is a group of angels surrounding a head representing God the Father. Below is a dove, symbolizing the Holy Spirit. On one side are two women, Mary the mother of Christ and Mary Magdalene, and on the other side two men, Saint John, the disciple, and Saint John, a Russian warrior. At the foot of the cross is an open rocky tomb with a skull within. This crucifix hung in a private chapel in a Russian home. On it Christ stands upon what is known as the *suppedameum*, an oblique support beneath his feet. The legendary reason for it is that through suffering one foot was drawn higher than the other. All representations of the crucifixion of the Russian-Greek Catholic Church are thus portrayed.

I found in Italy a large pendant crucifix of bronze that probably hung upon the wall of a chapel or private house. The nimbus and rays of glory are very prominent as is also the symbol of the skull and crossbones. It is of artistic workmanship and nearly three hundred years old. (Page 174).

Pectoral Crosses worn by bishops are in the form of the Latin Cross. The designs differ according to individual taste,—some very ornate and others extremely simple. The Pectoral Cross worn by archbishops and cardinals has a particular form. It has a short arm above the longer one. I have one of these Patriarchal Crosses that came from Mexico, it is over a hundred years old, made of plain handwrought silver. (Page 62).

Two other Pectoral Crosses I found in New Orleans.

I had gone there hoping to find some crosses in that old city, formerly the home of prosperous French and Spanish settlers. I wandered many times through its quaint old French quarter, fascinated by the overhanging, iron balconies, and the sun faded, blue-green, plastered walls of the old houses. I peeked into every charming little courtyard with its palms and ferns and wooden shuttered windows, and dropped into every antique shop, delighted and bewildered with the display of rare old furniture, silver, glass and other choice antiques, but found old crosses to be almost as scarce as in any modern midwest city. The few I saw were neither attractive nor unusual.

I strayed one day into a back street, lured by the hope of discovering a quaint old building or a fascinating balcony, and stopped to look in a shop window where were displayed some antique lockets, brooches and trinkets. The old shopkeeper of French descent, born some time antedating the Civil War, invited me in and with gracious manners and a delightful southern accent, inquired how he could serve me. To my doubtful inquiry for old crosses, he produced from a hidden drawer several very interesting ones. He explained that he bought old gold and silver to melt and had kept these crosses for years because they were too pretty to destroy. Nobody had wanted them, but in me he found an appreciative customer. I purchased several, among them two Pectoral Crosses. One of them was a Spanish cross, fully a hundred years old. It was an inlay of brass and steel, like the old Toledo blades and weapons. (Page 62).

The other Pectoral Cross was an ornate gold one, set

with amethysts, made in France, probably about the middle of the last century. (Page 62). They were both doubtlessly designed to be worn by bishops.

XI—BROADFOOTED CROSS

OUTDOOR CROSSES

XIV

FROM time immemorial men have erected monuments to commemorate great events or worthy deeds. Historic spots have been marked by a rugged boulder or towering shaft, on which are chiselled the record of the events commemorated. Heroes, statesmen, geniuses, philanthropists, all the great and distinguished ones through the ages have had monuments raised in their honor. Even those who have done no great deeds, or become in any way distinguished have had their monuments. The vast number of them in the burial places of the dead is almost incredible. It is a deep-rooted and universal custom.

Of the varied types and kinds of monuments, one symbolic design, the cross, has been perpetuated all through the centuries. Even in this machine age and materialistic civilization of ours the cross still possesses its symbolic significance.

Probably at no time in the history of the world has the cross been used as much as it is today both for commemorative and monumental purposes. Every soldier's grave on foreign battlefields, be he Catholic, Protestant, or Jew, is marked by a cross. Many memorial monuments

to those who died in the Great War, both in Europe and in this country, consist simply of a granite or marble cross with the crusader's sword carved upon its face.

Numerous Monumental Crosses are to be seen in every burial place in our country. Their variety is infinite and even bewildering. Scores of different shapes and designs are often to be seen in a single cemetery.

The symbolism and craftsmanship of all Monumental Crosses differ not only in the localities in which they are found, but in the centuries in which they were made. Creeds and beliefs, as well as symbology, differ with different peoples and times, just as the curious, often amusing, epitaphs on ancient headstones seem today in-credibly absurd or trivial, but were at one time of serious import.

There are still extant in various places in the old world many rare and beautiful stone Memorial Crosses carved with much artistic skill, with many curious traceries and symbolic designs. These were erected in memory of some beloved person or in commemoration of an important event. In England there are still to be seen some of these old Norman and Gothic Crosses erected upon several steps or surmounted by a Gothic turret. Modern me-morial monuments have reproduced somewhat the charm and beauty of these old Memorial Crosses. King Edward I had nine of them erected in memory of his beloved Queen Eleanor at the places where her body rested on the way from Lincoln to Westminster Abbey. Two of them still remain, much mutilated, one at Northampton and the other at Waltham. Charing Cross in London marks the

spot where her body last rested. The original cross there was completely destroyed three centuries ago and the Gothic one which took its place was erected about one hundred years ago.

There are many outdoor crosses that are not monumental in character. For ages past it has been the custom to raise crosses of wood, stone and bronze to commemorate great achievements such as the discovery or conquest of new countries, or to celebrate and record victories or historic events. Other crosses have been erected to mark certain buildings and places as set apart or consecrated to Christianity. These crosses are not only on church spires and pinnacles but on other buildings devoted to religious, educational, or philanthropic purposes.

There are also to be seen in numerous public squares and on many conspicuous hilltops throughout the world, great stone crosses, that proclaim that these are Christian towns or places. They are like great guide posts that remind the careless passerby of the religious faith of those who had them erected. Such a cross dominates the city of Montreal, reared upon a hilltop high above it. Another huge rugged cross towers above a crag of the Andes on the border between two South American countries.

Centuries ago it was the custom, long since abandoned, to erect stone or marble crosses in the busy marts of old cities where preachers stood upon a raised stone dais and exhorted the people. These were called Market or Town Crosses, as they usually stood in the squares or piazzas

near the open market places. It is supposed that the original purpose of these crosses may have been to remind the people who sold their products in these trading places to deal with their customers in a Christ-like way. Unless human nature has changed in the passing years it is to be feared that it would take more than a stone cross to prevent tricks in trade and sharp bargaining.

These Market Crosses were not only in various continental towns and cities, but in many old English towns. There are still some interesting ones in existence. In Winchester, Bristol and Chichester the Market Crosses are of an extremely artistic architectural appearance. In Cheddar and Malmesbury are large open, vaulted structures surmounted by Gothic turrets, beneath which on rainy days the market folk could stand while listening to the preacher as he stood beside the cross.

Many of the crosses in various towns were placed within carved Gothic structures of much beauty. Many old Market Crosses in Scotland were of this character. A few of them only are still in existence. From some of these, royal and civic proclamations were read besides the preaching of sermons. The principal purpose of the Market Cross was to bring the message of God to the busy throng that might not always attend services in the churches.

Wayside Crosses, beside which the wayfarer might stop and pray, are everywhere to be seen throughout various countries of Europe. For centuries past, men have been erecting them and thousands of them still stand, and

before them countless men and women daily stop and devoutly pray.

They were usually made of stone or wood with a shrine-like canopy over the cross or crucifix. Most of them are simple and unassuming in design, others very elaborate and artistic. The Gothic Cross, often seen in modern Monument Crosses, was derived from the ancient wayside shrines enclosing the cross or crucifix as well as from the Market Crosses.

Some Wayside Crosses were known as Weeping Crosses, where repentant folk knelt and repented of their sins. There might have been those among them who rejoiced in the opportunity to thus publicly parade their repentance for their misdoings, like the Pharisee of old, who remorsefully smote his breast and loudly prayed, with a holier than thou expression on his face. There have been found crosses, with a heart at the bottom, carved on the lintels of homes of some ancient Egyptians that tradition says were put there by the owners to denote that none but the good lived within. The Pharisaical spirit knows neither age nor clime.

Other crosses of strange import seemed particularly designed for the benefit of the wrongdoer. They were occasionally found in old cities and towns of Spain and Italy and were usually placed close to some ancient church. They were called Sanctuary Crosses, and to them the oppressed and the fugitive from justice fled for refuge. If he could reach the cross before he was overtaken by his pursuers, he had found sanctuary and was safe. He was

then given a black robe with a yellow cross on the shoulder to indicate that he was under the shelter and protection of the Sanctuary Cross. In this day when law-breakers and criminals flourish in our land, they doubtless would gladly welcome such havens of safety.

Boundary Crosses of bronze, iron and stone were used for many centuries in England to mark the boundaries of churchyards. They were not large or conspicuous, serving the same purpose as the plain stone markers, still in use, that indicate the limits of cemetery lots and private property.

Boundary Crosses were used occasionally by unscrupulous owners of real estate to mark their boundaries and thus escape taxation. A law was passed forbidding any man to set up a cross falsely upon his lands to pass them off as church property and thus evade tax. It would seem that from earliest times to the present men have always devised ways to dodge the tax collector.

The early Roman missionaries to England introduced the custom of having erected in churchyards an impressive stone cross. Small crosses to mark graves were not used until centuries later. On Palm Sunday a religious procession marched from the church to the great cross and decorated it with palms. It was sometimes called the Palm Cross and held in special reverence. On other occasions the bishop and his clergy and all the parish walked in procession with candles and crosses and laid grass and earth on the four Boundary Crosses marking the churchyard boundaries, and offered prayers to avert pestilences.

Of the large stone Celtic and Irish crosses probably the oldest kinds are known as Ionic and Runic Crosses. They have served as models for centuries past for Memorial Crosses. They possess a beauty of form and intricate design that has never been excelled, and while their archaic symbolism is not now often reproduced in sculptural art, the Ionic, the Runic and the Gothic Crosses are the inspiration of modern sculptors, just as Greek art and architecture still exert an important and inspirational influence and probably will continue to have that influence in spite of modern inane and inartistic tendencies. One of the most important of these ancient Celtic Crosses still stands on the little island of Iona off the coast of Scotland. Early in the seventh century Saint Columba, a devout Christian, and his little band of followers landed on the island. Here they built, with others who joined them, a monastery and founded a seat of learning. The place became in time so famous for piety and wisdom that pirates feared to attack and ravage the monastery. Great men made pilgrimages there and begged to be buried within the holy precincts of the island.

Tradition has it that no less than forty kings, including Macbeth and the one murdered, were buried within the churchyard, and three hundred and sixty stone crosses once stood within its boundaries. Of all these one only remains. It is known as Saint Martin's Cross, named in honor of Saint Martin of Tours who divided his cloak with a beggar not knowing He was the Master. The cross still stands, seventeen feet high, where it was erected nearly thirteen hundred years ago, weatherworn but still

beautiful. Like most old Celtic Crosses it is placed so that the worshipper faced the east. Entwined about the arms of the cross is an ornamental circle, the symbol of eternal life. Upon its face are sculptured human figures and queer unknown beasts. In the center within a circle is a representation of the Virgin and Child. The back of the cross is a mass of intricate involved tracery. In the center are five carved round bosses symbolic of the five wounds in Christ's hands, feet, and side. A curious design of interlaced serpents is quite noticeable. Possibly the serpents are symbolic of Saint Patrick of Ireland, or the incident in the Garden of Eden. The Serpent has long been a symbol of both wisdom and sin. There are people who still believe that wisdom comes by sinning.

The early Irish Crosses, derived originally from Scandinavian and Danish Crosses, are found in various places in Ireland and on the Isle of Man. They are known as Runic Crosses, so called because of the archaic lettering called runes with which they are inscribed. They are elaborately carved with much curious symbolic ornamentation.

These Celtic and Runic Crosses have been adapted and modified for use as modern monumental and memorial crosses. The Latin Cross, both in simple and decorative forms, has always held an important place for this purpose all through the ages.

PENDANT CROSSES

XV

Pendant crosses are of two distinct types—those of
a religious character, and the small crosses, purely
ornamental, worn for personal adornment.

Religious pendant crosses may be very large, such as
the great crosses and crucifixes that hang upon the walls
of churches, or very small, such as the diminutive cruci-
fixes attached to rosaries. Between these extremes are
an innumerable variety of sizes and kinds of pendant
crosses. They afford a fascinating study of the wide range
of artistic taste, symbolic thought and varied craftsman-
ship of different times and peoples.(Pages 78-134).

There is little doubt that a vast number of historic and
artistic crosses have been lost or destroyed. The proof is
the scarcity of old crosses. The unusual and rare designs
are difficult to find, particularly those made before the
seventeenth century. This is especially true of the English
and French Crosses. The fanatical zeal of Cromwell's
followers and the iconoclastic spirit of the French Revo-
lution destroyed the greater number of them.

In England the revolt against the use of the cross in
churches was rampant even in Queen Elizabeth's time.
Rood screens and shrines were demolished, and crosses,

crucifixes, and sacred statues were probably burned. The English reformers were even more rabid in their hatred of all papist emblems. Cromwell's fanatical followers destroyed most of the crosses and crucifixes that remained with bitter vindictiveness. They burned them to ashes or broke or hacked them to pieces. It is hard to understand how misguided Christians could thus vindictively hew and burn and wantonly destroy the symbol of their faith.

In France the atheistic wave that swept over the land in the terrible days of the French Revolution caused the destruction of countless crosses and crucifixes. In Russia, since the great upheaval of social and political conditions in our day, the destruction of crosses and other objects of art has been almost inconceivable. Through this senseless spirit of wanton destructiveness in these three countries the world has lost untold treasures of religious art.

Of the crosses that were made centuries ago in Italy and Spain, there are many still to be found. Their great variety of form and design and the beauty and quality of the craftsmanship is almost beyond description. All the rare skill of those wonderful metal and wood workers and gifted artists and craftsmen of the Renaissance, the golden age of art, was lavished upon the making and adorning of crosses and crucifixes. Goldsmiths and silversmiths rivaled each other in the beauty and charm of design and craftsmanship. They are to be seen in many of the old churches of Italy and may occasionally be found by collectors and lovers of rare and beautiful craftwork.

There are two large pendant crucifixes of carved wood

in Florence made by two famous fifteenth century artists about which an interesting story is told. One of these, in the church of Santa Croce, was made by Donatello and the other, the handiwork of Brunelleschi, is in the church of Santa Maria Novella. Vasari, that more or less truthful chronicler of the lives of the artists of the Renaissance, tells the tale, which runs somewhat like this.

Donatello, with much pride showed to Brunelleschi a large wooden crucifix he had just carved. With frankness most discouraging, his friend told him that he had not made a Christ, but a peasant, nailed to the cross. Donatello, naturally peeved, intimated it was easy to find fault and suggested he try to do better. One day, returning from market with his apron full of fruit, cheese and eggs for their breakfast—the two lived together—Donatello was shown a crucifix so far surpassing his that in his astonishment he threw up his hands, dropped his apron and spilled its contents on the floor. Without regretting the lost breakfast he magnanimously declared:—"I see truly that you are made for Christs and my art is fit for nothing more than peasants."

Donatello may and may not have said anything of the sort, but the tale aroused my interest sufficiently to see the two crucifixes. The difference between them is decidedly noticeable. One is of the peasant type, rugged, masculine and material. The other a delicately modelled figure suggesting tenderness, resignation and spirituality.

All of the old handmade crucifixes have a charm and individuality not possessed by the later ones made from dies or molds.

All of the smaller religious pendant crosses are made of a great variety of materials. Not only of wood, carved, gilded and inlaid, but of various metals, gold, silver, bronze, iron, brass, and pewter. Also of semi-precious stones and jewels, ivory, pearl, and tortoise shell.

Of the many kinds of pendant crosses that have been made in all the ages past there are two that possess distinctive characteristics. One of these is the Reliquary Cross and the other, for lack of definite nomenclature, might be called the Angel Cross.

Reliquary Crosses are designed to hold sacred relics, the bones of saints and other cherished and revered relics. They differ widely not only in design, but in the way in which they may be opened to place within the relic to be preserved. In some this is concealed completely, in others it may be partly seen. They usually open from behind and the means of closing and securing them is sometimes very ingenious. Reliquary Crosses and Crucifixes are hung in chapels and on the walls of homes. (Page 94).

Angel Crosses probably owe their inception to the paintings of the old masters, some of which are still to be seen in the churches and galleries of the old world, in which the cross is shown either supported or upheld by angels. In some pictures they seem to be bearing it up to heaven, in others they are standing at the foot. Crosses and crucifixes with angels upon them have been made since the seventeenth century. They vary in design as do the paintings which probably were their inspiration. The angels are sometimes at the intersection of the arms, some-

times at the base, and occasionally appear at the extremities of the arms merely as little fat cherub heads. (Page 110). In no other form of the cross or crucifix is the distinctive difference in the craftsmanship of different peoples more conspicuous. The angels really appear to be of different nationalities as is sometimes apparent in the personages in old paintings. The Madonna may be Italian, Spanish or Dutch, according to the nationality of the artist or his model.

There is an old legend that may account for the appearance of angels upon the cross. Once upon a time, long centuries ago, a Spanish priest was captured by a Moorish king, who commanded him to say mass. Having no cross available, the priest refused to do so. The enraged Moor would have had him immediately slain but for the intervention of a miracle. Two angels suddenly appeared bearing between them a glittering cross, and the priest was rescued from a martyr's fate.

Small ornamental pendant crosses worn for adornment were much in vogue among ladies of taste and fashion in this country a generation or two ago, but are now seldom worn. They had been used for centuries past in the old world. They differed greatly in artistic craftsmanship, some very simple, others of delicate or elaborate designs, adorned with jewels or semi-precious stones. Of those made in the nineteenth century, many of which were produced in this country, the favorite materials were gold and silver. Small crosses made of wood taken from famous ships or historic buildings tipped with gold and

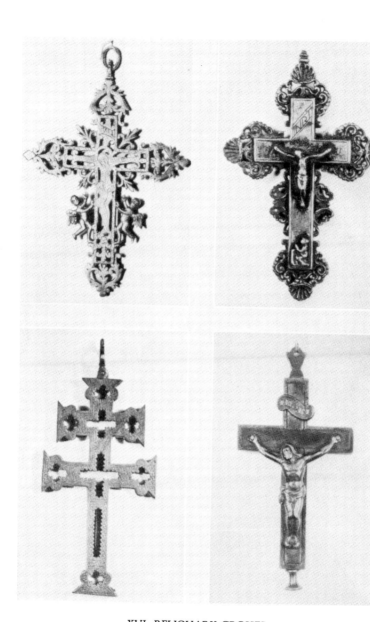

XVI. RELIQUARY CROSSES

SICILIAN—*Silver*
Symbolic Christ Figure with Angels
1700-1725

SPANISH—*Bronze*
Chased Open Design. Relics Shown
1750-1775

ITALIAN—*Silver*
Pilgrim Cross—Shell Design
1725-1750

ITALIAN—*Bronze*
Closed Design. Relics Concealed
1725-1750

also crosses of onyx and gold with small pearls were favorites. There was also a great number of crosses, some of rare beauty, made throughout Europe of pearl, ivory, onyx, mosaic, pinchbeck, Whitby jet and other materials.

Ornamental personal crosses have been worn for ages past by French, Spanish and other peasant women to complete their costumes. They were mostly simple, inexpensive designs, but occasionally there are curious and intricate patterns among them, suspended from handmade silver chains.

Many years ago on a hillside path in Capri, I met a husky, olive-skinned peasant wearing a beautiful old cross of ornate design. A visible offer of sufficient lira— we were linguistically handicapped—tempted her to part with her cherished heirloom. It was a plain gold cross overlaid with handmade filigree design, more than a hundred years old. (Page 126).

One of the delights of collecting old crosses, or other antiques, is that it takes the collector into all sorts of out-of-the-way places and in contact with queer, interesting people. The pleasures of the search are more often in unexpected experiences than in treasures found. Old crosses that are worth the getting are exceedingly scarce and hard to find. I remember once, when on such a quest in the ancient Spanish city of Cadiz, meekly following a haughty Spaniard, wrapped in impressive silence and a worn-out cloak. He led me by devious ways and crooked streets to a locksmith's shop. I was invited to ascend a winding iron stairway in the rear of the shop with much

incomprehensible conversation and violent gesticulation.
I declined, but the haughty stranger barred my retreat. I
climbed the stairs with fear and trembling, disturbed by
unpleasant thoughts of stilettos and Toledo blades hidden
under the fierce looking Spaniard's cloak. It was a dread
not realized. The locksmith was a brother collector, and
the walls of his upper apartment were hung with beauti-
ful fabrics and ancient weapons and his cabinets held a
rare collection of old Spanish jewels, reliquaries, and
crucifixes. I secured an old cross of garnets in an exquisite
setting of gold filigree. The haughty stranger thereupon
accepted a tip with the impressive dignity of a Spanish
Don and we parted with kindly feelings and courteous
bows. (Page 134).

Besides this garnet cross I have a number of ornamental
crosses that are quaint and unusual. Others are beautiful
and more conventional. Several attractive little ones were
heirlooms and given to me by friends. A cross I par-
ticularly value is the handiwork of one much beloved, who
has passed on. It is an artistic silver cross set with a single
amethyst. (Page 134).

Most of my ornamental crosses I found in various
countries. Many of them are of conventional designs,
others distinctive, like an Italian filigree silver cross
(Page 126) and an Italian gilded cross (Page 126) and a
Russian silver cross which has upon it five round disks
called bosses, symbolizing the five wounds of Christ.
(Page 126). These were all made during the last century.
Another, much older, probably of the seventeenth cen-
tury, is a silver cross from Belgium. It is of elaborate de-

sign set with flat cut old style diamonds. (Page 134).

Women have always worn jewels and decorative orna-
ments. It is not strange or unnatural that the cross has
been worn frequently and in various countries for cen-
turies past and is still a cherished adornment.

AMULETS AND THE CROSS

XVI

SUPERSTITIONS are inherent in the human race. A belief in evil spirits and imaginary demons has existed from the days of the cave man. Signs and omens and sinister spells have troubled mankind ever since. To ward off their malignant powers men have put faith in talismans and amulets, and from earliest times to the present have worn charms and amulets to protect themselves from evil spirits.

The swastika was believed not alone to be a symbol of health and welfare but a charm against evil influences and was put not only upon pottery and monuments but worn as a talisman.

The belief that human life was influenced by both good and evil spirits was almost universal. Both to propitiate and to protect, amulets and charms of all kinds have been worn by the inhabitants of all countries from prehistoric times.

The ancient Hebrews were particularly addicted to the custom, although the wearing of cabalistic charms was strictly forbidden. They were rather given to doing what was prohibited—not unlike some moderns. They may have acquired the habit from the Egyptians, who were

much given to the use of amulets, and wore them to guard themselves from magical and evil influences. Also to protect their dead they put scarabs, bright colored beads and little clay figures of their gods in the tombs.

Centuries later it was the custom among some Christian nations to bury a cross with their dead. Even to the present time small bronze crosses are often fastened on the outside of tombs in Italy and Switzerland. To denote the resting places of Christian men and women would doubtless be the explanation but it probably is the perpetuation of an ancient custom. I have two of these bronze burial crosses. One of them of an incised conventional design from a tomb in Italy (Page 150), the other of a raised floral design from a tomb in Switzerland. (Page 186).

Superstitious beliefs have prevailed all through the ages. The glass witch balls of the early New England settlers hung in the windows were believed to be a protection from witchcraft. As long ago as the seventh century the Council of Trullo excommunicated all makers of amulets and branded the custom of wearing them as a heathen superstition. But superstitions have an alluring grip on many people and even this wise decree failed to banish them. Even to this day there are in the world a vast multitude who fear the devil and all his evil ways and cling to the belief that he may be defied by various charms and talismans.

The materials of which amulets have been made are as varied as the shapes in which they have been fashioned. Shells from earliest times have been used as charms and amulets and were supposed to be of great virtue. In some

eastern countries, women and children still wear shells about their necks to protect them from the evil eye, and shells are frequently hung upon mares and she-camels for the same protective purpose.

The pilgrims of olden times wore cockleshells in their headgear as charms against spiritual foes. On these shells were sometimes crude drawings of the crucifixion, the Virgin or some saint, or other sacred personage.

It is still a prevalent custom in many parts of Italy and Spain to put upon the harnesses of horses and donkeys various charms made of silver and other materials to protect them from all evil influences. Small bells are suspended from donkeys' necks as luck charms.

Among the peasants of many countries amulets are still worn almost universally. They are often in the shape of the cross and sometimes small silver bells are attached to them and worn by children. The tinkling bells are believed to be a warning to evil spirits of the benign influence of the cross. (Page 78).

The sign of the cross not only is used in conferring a spiritual blessing but also is believed quite generally to be a protection from evil and temptation. In ancient times, it was considered most efficacious for the exorcism of demons and its use still prevails by superstitious persons who fear calamity. Many people who would not make the actual sign of the cross seek to avert a dire happening by crossing the fingers.

Due perhaps to the innate vanity of humanity, colored beads and even jewelry have been often used as charms. Beads and stones of various colors, blue predominating,

have been found in excavations in various places of the ancient world, which were worn not merely for orna-mental purposes but to protect the wearer from the evil eye which was believed to sometimes cause death. Charms in the shape of ornaments and semi-precious stones were worn to bring good luck. Soldiers wore them for protection in battle. Jewels were worn to guard various parts of the body such as the nose, ears and neck from the entry of evil spirits. A ring in the nose and ear-rings in the ears prevented evil from penetrating and the necklace upon the breast protected the heart. Thus there is excuse and justification for adorning the person with beautiful jewels. It became an established custom long after it ceased to be a superstition and women have con-tinued ever since to so adorn themselves.

Many amulets and charms are worn to protect from the malign influence of the evil eye. For centuries there has existed a superstitious belief that certain persons are endowed with diabolical powers which they exercise merely by looking upon their innocent victims. A foolish superstition it would seem to most sensible people who scorn to wear charms to ward off evil or cure disease but still have faith in the efficacy of rapping on wood and be-lieve it unwise to walk beneath a standing ladder. To find a four leaf clover is still considered a harbinger of good luck. Its rarity and the resemblance to a miniature Maltese Cross may have been the reason for the prevalent belief that it is a talisman.

The mistletoe was, in ancient times, called the Wood of the Holy Cross and to it was attributed healing virtue

in diseases of old age. There is a tradition that the mistletoe was once a tree and from it was made the cross upon which Christ was crucified. It has for centuries been a favorite decoration at Christmastide. The traditional privilege of kissing under the mistletoe comes probably from its prominent use in the Saturnalia of the pagans.

During the Middle Ages, small Reliquary Crosses were very popular as amulets. They contained the bones of saints, stones of symbolic import and other sacred relics. They were believed to be valuable for the prevention of evil influences and temptations and also particularly beneficial in the cure of diseases.

Among savage races and uncivilized peoples the use of curious and often weird looking charms has always been an extremely prevalent custom. Among more civilized nations, amulets were usually more artistic and valuable. Both semi-precious stones and rare gems were used and various objects in gold and silver made by skilled craftsmen. As the fashion for wearing jewelry grew in popularity and the amulets were more or less beautiful in design it was perhaps a natural evolution that the cross itself should become a most prized talisman. What could be a greater protection against evil and temptation?

Small ornamental crosses of different shapes and designs, many of them adorned with jewels, were made of gold, silver, mosaic, jet, amber and other materials. Many were very elaborate and ornamental; others, simple in design. The demand for them and their use became widespread in both Europe and this country, particularly during the latter half of the 18th century and the first half of

the 19th century. While many people wore crosses as amulets; the greater number, were worn as ornaments, as they wore pendants and lockets which were much in vogue during that period.

The oldest cross I possess may have been worn originally as an amulet. It is a Coptic Cross obtained in Cairo from a well-known antiquarian who guaranteed its genuineness and probable date as early in the 10th century. (Page 158). It is of bronze, crudely made with simple incised design, and is in the form of the Greek Cross. It is not large and could easily be worn upon the neck. It was found in Egypt and had probably been buried for many years. That it is a Christian Cross is undeniable from its form and the fact that the Copts were from Biblical times, a Christian people living in the valley of the Nile. Surrounded by millions of Mohammedans, the Copts are the descendants of a pure unmixed race, still living where their forefathers lived. They became Christians centuries ago when the country was under Roman and Byzantine rule. They are of Egyptian ancestry and the Coptic language, similar to the ancient Egyptian tongue, is still used in church services although the Arabic is the language generally spoken. The Copts live in scattered communities all over Egypt. Their religion is still Christian in belief and observances but decadent in many ways. There is a numerous clergy, mostly poor and illiterate, and the services held in a few ancient monasteries and dilapidated churches are very monotonous and unimpressive, beginning at daybreak and continued at intervals all day with prolonged readings of the Scriptures without

sermons or songs. The worshippers stand leaning on crutches. The Patriarch is claimed to be a direct successor of St. Mark. The principal church is in Cairo. It dates from the 6th century, and is known as the Church of Mary. It is reputed to have been built over a grotto in which Mary lived with the infant Jesus when in Egypt.

SYMBOLS ON THE CROSS
XVII

SYMBOLS seem to have been essential to the thought of all ancient peoples. Pagan art is full of symbols and the number and variety of them in Christian art is fairly bewildering. Their importance and extensive use was due to the ignorance of the masses. In an illiterate age, when few could read, simple means had to be used to reach their understanding. Symbols and pictures and the frescos and mosaics in the old cathedrals told the Bible stories and truths and emphasized the doctrines of the church which otherwise would never have been known. They were the poor man's Bible.

The Fish, usually a dolphin, symbolic of the Christ, suggestive of water and the rite of baptism, was the first Christian symbol. It was also suggestive of Christ's injunction "Follow me and I will make you fishers of men."

The Lamb, typifying Christ the Lamb of sacrifice, was an early symbol much used. The Lamb occasionally was pictured bearing a banner signifying Victory. It was also symbolic of the prophecy that Christ was the "Lamb of God, dumb before his shearers."

Another very early symbol of Christ was the Lion. He was called the Lion of the tribe of Judah.

The Star is still another emblem of Christ. The five-pointed star represents the Star of Bethlehem. It is the Christmas emblem still in use. The six-pointed Star represents the Creator, who is more frequently represented in early religious art by a Hand, issuing from clouds or reaching down in benediction. God the Father was later represented by the head of a venerable man with full beard and a halo or rays of glory. Another symbol was the Hebrew word Jehovah, in a combined circle and triangle, symbolic of eternity.

The symbol of the Holy Spirit is the Dove, an early emblem still in use. Its inception and justification as a symbol is in the Gospel account of the baptism of Christ and the descent upon Him of the Holy Spirit like unto a Dove.

The symbol of the Trinity most familiar is the Triangle. Its equal angles or sides represent the equality of God the Father, the Son, and the Holy Spirit. This unity is also expressed in intersecting Triangles, Circles, or other three-fold forms of ornamentation.

In the Metropolitan Museum of Art in New York is a collection of small Roman lamps of terra cotta made between the third and the sixth centuries. The interesting thing about them is that they all bear early Christian symbols molded on the little olive oil lamps. The Fish and the Lion, symbols of Christ and of Christianity, the Pigeon, symbol of the Soul or Vigilance, the Hare and Cock supposed to have the same significance, the Palm tree typifying Victory, and the Peacock, Immortality. All these Christian symbols were on these ancient lamps.

Among other symbols to be found in early Christian art were the Serpent, symbolizing Sin, also Wisdom; the Crown, an emblem of Victory; the Skull representing Death; the Dragon, symbolic both of Satan and Sin; the Ass, emblem of Peace and Sovereignty; the Horse, emblem of War and Turmoil; the Palm, symbol of Victory and also of Martyrdom; the Lamp, Piety or Wisdom; the Olive Branch, Peace and Reconciliation; the Anchor, Hope and Steadfastness of Purpose. The Pelican was also an early symbol. It was a legendary belief that she was a bird that tore open her breast to feed her young and was symbolic of Redemption through the sufferings of Christ.

All of these symbols are to be found frequently in religious art, in paintings, frescos and mosaics, and occasionally on crosses and crucifixes.

The Cross itself is the greatest and most significant of all Christian symbols. It typifies the Savior and His sacrifice, the symbol of Suffering and of Salvation. It has sometimes been designated as the Passion Cross and also the Cross of Calvary. As such, it is always upon a base of three steps, symbolizing the Trinity, also the three Christian virtues, Faith, Hope, and Charity. The four points of the cross was a symbolic reminder that the redeemed were from the four quarters of the earth.

The first crosses were simple in design, devoid of symbols or ornamentation. As they became more elaborate and were embellished with jewels, symbolic objects were added. The first of these was the Lamb, typifying Christ, and this emblem still prevails to this day on some Processional and Altar Crosses. The Serpent, signifying

Satan or Sin, early appeared on crucifixes. It was placed below the feet of Christ, signifying that sin had been conquered. It was several centuries before its use was abandoned in pictorial art. The devil was always hard to down.

Soon after the crucifix came into use symbols and sacred personages appeared upon it—the Sun and Moon, symbolizing Christ's dominion over day and night, the Skull and Crossbones depicted on the lower part of the cross, a symbol still in use, signifying His triumph over death. Another meaning attributed to it was that it represented Adam through whom sin entered the world, and the crucified Redeemer hanging above upon the cross. (Page 174).

On all of the early crucifixes the crown upon Christ's head was one of glory, not a crown of thorns, and it signified victory over death. The nimbus or aureole, or rays of glory which appear on many old crucifixes that do not have the crown of thorns, has the same significance. In religious art the nimbus appears back of heads of saints or martyrs to distinguish them as such. (Page 174).

The Dove, symbolizing the Holy Spirit, came early into use and appears on some later crucifixes. The Dove is always above the head of the crucified Christ. (Page 118).

The Triangle symbol occasionally appears on crucifixes, usually surrounding the head or hand representing God the Father. (Page 30).

The Circle entwining the arms of the cross is emblematic of eternal life. It is a symbol that has been constantly and frequently used all through the ages. (Page 150). The Circle is sometimes combined with the Square. This is the

symbol of earth and heaven. The Square represents the earthly life, and the Circle, eternity, the heavenly life and the Square within the Circle typifies that life is eternal. The Circle in Monumental Crosses, known sometimes as the wheel, is often ornamented with a rope design, still symbolic of eternity—an endless life. Where the Circle is ornamented with a series of small disks it typifies a jeweled crown, as the plain circle is supposed to represent the crown of thorns. In the early crosses that were elaborately ornamented and adorned with precious stones, rubies and carbuncles were used at each end and in the center to represent the five wounds of Christ in His pierced side and hands and feet.

The five bosses or round knobs found on some ancient stone crosses and often to be seen on modern monumental cemetery and some pendant crosses are also symbolic of the wounds of Christ. (Page 126.)

The cross is often adorned, especially in Monument Crosses, by flower designs. The Passion flower, also designated as the True Vine, to which Christ compared Himself, is a particular favorite. (Page 118). The Lily, typifying purity and also the resurrection is another flower often used.

Angels appear in some early paintings of the crucifixion and on many old crucifixes. Their significance is not very apparent. It might be that the early painters and crafts-men thought it necessary to show that heavenly beings were present to comfort and sustain in the hour of suffer-ing and death. There is a curious fourteenth century painting in the Cochrane Art Gallery in Washington of

the crucifixion, in which Christ and the repentant thief are attended by a group of angels and the bad, unrepentant one by a swarm of little devils.

I possess several crucifixes from different countries with representations of angels upon them, all differing decidedly in their positions, expressions and general appearance. (Page 110). One Italian silver, floriated reliquary cross made about 1700, has a very curious representation of the Christ with trefoil terminations instead of hands and with the legs twisted in a remarkable position. Angels on either side of the cross with uplifted hands appear to have been flying and to have just alighted on the cross. (Page 94). On another Spanish bronze crucifix, made about 1650, the flying angels are clinging to either side. On the reverse they are apparently little devils instead of angels. On this crucifix are also the Virgin and the sun, moon, and stars. (Page 110). On some old crucifixes instead of representations of the heavenly bodies, are draped female figures with emblems of the sun and moon on their heads.

On the other crosses the artistic craftsmanship differs materially. The angels on the two Italian ones are quite similar but in all other respects the crosses are decidedly different. The angels on the French cross somewhat resemble cupids. On all of them the Christ stands upon a *suppedaneum* or support and is without a crown of thorns.

Many old crucifixes have figures of sacred personages upon them. These are known as Inhabited Crosses. The Virgin appears most frequently either alone or holding the infant Christ, or with Saint John, the beloved

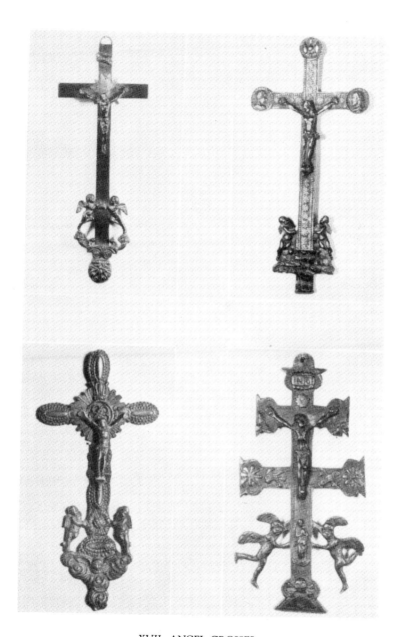

XVII. ANGEL CROSSES

FRENCH—*Bronze and Wood*
Symbol, Rays of Glory
1775-1800

ITALIAN—*Bronze*
Symbol, Circles, Eternal Life
1750-1775

ITALIAN—*Bronze*
Symbol, Dove, Holy Spirit
1750-1775

SPANISH—*Bronze*
Symbols Sun, Stars, Moon
1650-1675

disciple. They are represented either by their heads only or by full figures. On some crucifixes are Mary the Mother of Christ and Mary Magdalene. (Page 158).

I have a very curious carved pearl crucifix from Hungary made about 1575 which has upon it full length figures representing the three Marys, who are recorded by Saint John as having stood near the cross when Christ was crucified. All of them have one hand to the cheek, an expression of grief as depicted in ancient art. It is crudely carved with the Savior merely resting against the cross, not nailed to it, as represented in the very early crucifixes, with the Dove above His head and a very curious skull and crossbones beneath His feet. (Page 174).

On many old crucifixes appear the heads of the four evangelists, or their symbols, the Man for Saint Matthew, the Lion for Saint Mark, the Ox for Saint Luke, and the Eagle for Saint John. Besides these, other saints, known and unknown, are occasionally represented on old crucifixes.

I have an old carved pearl and wood Italian Processional Crucifix, made early in sixteen hundred, that is fairly overladen with sacred personages and symbols. Above the figure of the crucified Savior is the Virgin with the infant Christ in her arms, and on either side Saint Mary Magdalene and Saint Veronica, with her handkerchief bearing an imprint of the face of Christ. Below is the angel Gabriel and Saint John, the apostle, with a banner and a sword, and the figure of a woman, either the Virgin or an unknown saint. On the reverse of the crucifix is the Virgin, a full length figure with a nimbus over her head

and clasped hands. Surrounding her are the heads of the four Evangelists with their symbols. Other figures and symbols, besides an intricate pattern of symbolic designs, are upon this most elaborately adorned crucifix that was carried centuries ago in processions through the aisles of some old church in Italy. (Page 30).

The love of symbols has always been a universal trait in man. Strange and inexplicable as it may be, symbols still have a powerful influence that neither the puritan, the iconoclast, nor the modern materialist could conquer. In fable and in history, all through the ages, there have been symbols. The lyre of Apollo, the hammer of Thor, the serpent in the wilderness, the eagles and the bundles of faggots of the Romans, the totem poles of uncivilized Indians, and the flags of all civilized nations are all symbols of great significance and influence.

The multitude of emblems in use in the world today is beyond comprehension. Nearly every country, state, and municipality has its emblem, and almost every club and fraternal organization has a distinctive one to distinguish it from all others. If social and political organizations have recognized the value of an emblem to which their members may owe allegiance, it makes clear and more easily understood why the followers of Christ have made such extensive use of so many different symbols all through the centuries.

THE SIGN OF THE CROSS

XVIII

LONG before the cross itself came into general use the sign of the cross was used, not only in religious services but on many other occasions. As far back as the third century Tertullian, a writer of that time, made this comment on the custom—"At every coming in and going out, in putting on our clothes and our shoes, in the bath, at table, lying down or sitting, we mark our foreheads with a little sign of the cross."

In the ceremonious observances in religious worship of that time it was natural that the sign of the cross should have been frequently used. It would hardly seem possible that it should have been in such common use as Tertullian claimed it was in his day. If true, it was a custom no doubt due to the almost universal belief in demonology. For centuries before and after the Christian era most people had a very lively faith in demons and devils of all sorts and kinds. This belief was prevalent alike among peasants and philosophers. In the Scriptures are many references to unfortunate persons who were possessed by demons and many instances recorded of demons being cast out.

Insanity, epilepsy, melancholia, hysteria, and even blindness, dumbness and deafness were considered the

diabolical work of demons. Science and medical knowledge and skill have routed these devils, but for centuries the world firmly believed that men and animals became literally possessed of demons that were the cause of their strange symptoms and actions.

Demons were also thought to be responsible for thunderstorms, cyclones and tornadoes. In fact evil spirits were believed to be everywhere prevalent, ready and waiting to pounce upon the unwary as does the present day pestiferous microbe.

It was a natural evolution of thought to make use of the sign of the cross to exorcise the demons that brought these afflictions to mankind.

There is recorded somewhere the sad case of a beautiful nun, young and hungry, who forgot to make the sign of the cross before eating and unhappily swallowed a malicious little devil on a lettuce leaf.

Those early Christians not only used the sign of the cross to ward off evil spirits but branded their cattle with a cross to protect them from disease. Even latter day Christians of the seventeenth century in New England sometimes marked their houses with a cross to keep out witches.

Silly, foolish superstitions they seem to us. Probably some of our beliefs and customs may be thought just as absurd a few generations hence.

Another prevalent belief of men in ages long past was the omnipresence of angels. The Scriptures are filled with angelic visions and communications. Angels seemed to be the natural and appropriate messengers between God

and man. Men believed in them as they did in demons without question or doubt. It was through angels they thought God communicated his desires and his commands to men. This explains the appearance of angels on old crosses and in the pictures of the old masters.

To this day many people in various countries wear amulets upon their persons, and attach curious silver trinkets, in symbolic forms, to the ornamented harnesses of their horses and donkeys to ward off the evil eye.

Bells were supposed to have power against evil spirits and were attached to crosses as charms to keep them away. I have a little silver eighteenth century crucifix with three little silver bells attached, that was once worn by some Russian peasant woman or child to ward off the dread power of the evil one. (Page 78).

From this idea of associating bells with the cross may have arisen the use of bells in church towers to call people to worship. The earliest known church bell was made and hung in an ancient church tower in the town of Campania, Italy, in about the year five hundred, and from it was derived the Italian name Campanile, a bell. tower.

In religious art Saint Patrick of Ireland and Saint Anthony of Padua and other saints are sometimes pictured as carrying crosses with bells attached, not only to warn away evil spirits but to attract the poor and needy to whom they gave alms. Tradition tells of how Saint Anthony was followed always by a throng of the sick and hungry who, attracted by his tinkling bell, followed him as he wandered about the countryside, and to whom he ministered alms and physical and spiritual aid and solace.

It is claimed that the early Christians prayed standing with their arms extended, forming with the body, the shape of the cross. If they did so it was a custom that had prevailed for many centuries among various peoples. The ancient Hebrews among others, it is claimed, assumed this posture in prayer.

The sign of the cross has been used almost from the dawn of Christianity until the present time. It is made with two, three and five fingers, each having its own particular significance. When five fingers are used it is a reminder of the five wounds of Christ, when three fingers it signifies the Trinity, and two fingers denote the two-fold nature of Christ, the human and divine. The passing from left to right signifies the remission of sins; the separation of the goats from the sheep. When the sign of the cross is made with the first two fingers open the forehead is touched in the name of the Father, the breast in the name of the Son, and from left to right in the name of the Holy Ghost. The sign of the cross has been in use since Apostolic times. It is a confession of faith in Christ and an expression of gratitude and reverence.

It is told of Saint Patrick, the patron saint of Ireland, that when preaching upon the hillside, he plucked a shamrock and held it up as a visible sign of the Trinity, to illustrate and prove the doctrine that what was seemingly three was in truth one only.

There is to this day in many lands a custom among children, and even their elders, to cross the fingers for luck or to avert danger. Many people cross their hearts when pledging secrecy or making some important promise.

There is another sign of the cross having a legal, not religious, significance. It is the cross mark made by illiterate persons unable to sign their names to deeds, wills, and other legal documents. This custom of attesting to the validity of important documents by inscribing upon them a cross has been in use for centuries.

Another curious use of the cross symbol was the design of the panelling on many doors in olden times, which resembled quite distinctly the form of the Latin Cross. This was not an accidental construction but deliberately designed. These interesting old doors, panelled to represent a cross, are still to be seen in various old towns in our country. There is traditional authority for the statement that they were so made in obedience to a royal mandate of an English sovereign to his loyal colonists in America. However true or otherwise this may be, there are many such cross-panelled doors still existing. In the historic Sunrise Tavern in Fredericksburg, Virginia, often frequented by George Washington and where he and his mother attended a reception and ball given in honor of the victory at Yorktown, are still to be seen several doors bearing the design of the cross.

Another cross sign is to be seen on the vestments of the clergy and embroidered upon altar cloths. It is called the Canterbury Cross. In form it resembles the capital letter Y, and symbolizes the lifting up of Christ's hands and arms when crucified. The chasuble of Saint Thomas of Canterbury, now in the Cathedral of Sens, France, has the Canterbury Cross embroidered upon it and is probably the oldest vestment bearing that cross sign.

Another sign, symbolic of the crucifixion of Christ, is known as the Stigmata. It is a mysterious mark miraculously set upon a few deeply spiritual, self-denying followers of the Christ, the imprint of His wounds upon their hands, feet and breasts. The first chosen one claimed to have received this remarkable sign was Saint Francis of Assisi, that unselfish, lovable man, who gave up riches and power to become poor and humble and who devoted his life to doing good unto others. Towards the end of his life of devotion and sacrifice, when sick and weary from long journeyings, praying before the dawn upon a lonely mountain top in the midst of a forest filled with the birds that he dearly loved, Saint Francis had a vision of a seraph with wings shining and aflame, and in the strange illumination he saw what seemed to be like unto the crucified One. Infinite pity and peace and great spiritual joy filled his heart. When the dawn came his followers saw upon his hands and feet marks that he bore till his death like the nail prints of his crucified Savior.

In all the years that have passed since Saint Francis died, the number of those even reputed to have borne the mark of the Stigmata are exceedingly few.

In the fourteenth century in the ancient town of Siena in Italy, lived Saint Catherine, the first woman, it is claimed, who was marked by Stigmata. Her loving nature, saintly character, and tender sympathy and charity for the sick and needy, endeared her to all who knew her. Not only the poor and humble folk but the rich and powerful were influenced by her words and deeds. She quelled riots and political dissensions and her reputation for great

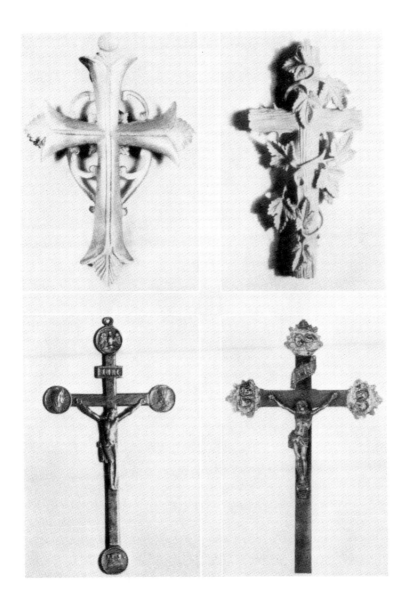

XVIII. SYMBOLIC CROSSES

ITALIAN—*Floriated Pearl*
Symbol of Spiritual Growth
1850-1875

ITALIAN—*Bronze*
The Dove Symbol of Holy Spirit
The Lamb Symbol of Sacrifice
1800-1825

GERMAN—*Ivory*
Symbol of the Vine
1825-1850

SICILIAN—*Pewter, Brass, Wood*
Symbol of Guardian Angels
1750-1775

piety and power spread far beyond her native city and land. For many years the Papal See had been voluntarily exiled to Avignon. Dante and Petrarch had failed in their efforts to restore it to Rome. Saint Catherine of Siena, daughter of a humble dyer, succeeded where they had failed. She persuaded Pope Gregory XI by her untiring efforts and personal appeals, to abandon his luxurious palace and fawning courtiers in Avignon, and to establish again the papacy in Rome.

Her many activities and frequent fastings wasted her strength and shortened her life. It was in a little church in Pisa, five years before her death in 1380, she received the Stigmata. She described it herself in these words— "There came down from my Savior's wounds five bleeding rays."

More than one artist has recorded the miracle. There is a painting by Matteo Balducci, in the church of Santo Spirito in Siena, that portrays the Assumption of the Virgin who is represented between Saint Francis and Saint Catherine, who bear upon their hands and feet the imprint of the Stigmata.

RELIGIOUS ART AND THE CROSS

XIX

THE cross is often portrayed in art—in sculptured stone and marble, in artistic craftwork of wood and metals, in glowing tints of stained glass, in colorful intricate mosaics, in soft-toned frescos, and in painted pictures.

In paintings, as in other artistic productions, the cross is either depicted alone and distinctive, or as incidental in a pictured scene or event. The crucifixion is of all such subjects the one most often painted, and the cross, with the crucified Christ upon it, is the central object in the picture.

There are many other old paintings in which the cross might be called an accessory. If held in the hand of a saint, it usually denotes that that particular saint was a follower of the cross. In some instances it is a symbol, as in the case of John the Baptist, who is always pictured with a cross. When he is represented as a child he holds a cross and is accompanied by a lamb. Saint Helena is always painted with a cross beside her, or holding one, as a reminder that it was she who found the original cross. In this instance the cross is an attribute, not a symbol.

The religious art of the Renaissance filled an important

place in the life of that time. Few people could read or write and the painted picture was invaluable as an interpreter and exponent of religious truths.

The art of the Primitives was purely symbolic. Historic or realistic accuracy was not attempted. No portrayal of actual events or of scenic backgrounds was painted. The favorite subjects were the Madonna and Child angels and saints, painted in distemper, in soft colors on gold backgrounds. The simplicity of theme and formal conventionality gave to them a distinctive charm.

The golden age of art brought with it not only a glorious mastery of color and drawing, but a wonderful development in pictorial art. Artists had learned how to mix and use oil paints and to put upon their canvases more realistic and truthful representations of sacred personages and events. They still painted the Madonna and saints, but not merely as formal portraits, without any interesting details or accessories, but portrayed them and a great number of other Biblical characters as living amid natural surroundings and attractive landscapes and depicted the important events in their lives. These paintings of the Old Masters were an open book of the Scriptures and told and illustrated its truths and narratives so that all who looked upon them could understand. They were not always historically accurate, but were pictorially and symbolically graphic enough to be of great value.

The sacred personages were sometimes overdressed in too gorgeous raiment and overloaded with jeweled ornaments. The Madonna was occasionally associated with latter day saints or unknown but wealthy art patrons.

The patriarchs and prophets of Israel sometimes dwelt under soft Italian skies and beside sunny Tuscan slopes. In spite of these pictorial inaccuracies the art of the Renaissance was a distinctive advance over the formalism of the early Primitives, and will always be an artistic inspiration.

The favorite subjects painted were not only the Madonna and Child and innumerable saints and tortured martyrs, but many memorable events and dramatic incidents narrated in both the Old and New Testaments. Chief among all of these was the representation of the crucifixion. Over and over again was the tragic scene painted and the manner and pictorial quality of its representation differed widely. The cross itself, as painted by different artists, often differed in appearance. Always the simple, plain cross, sometimes it was much shorter than it was usually represented. Occasionally it stood upon a rocky base to represent Calvary, but more often was implanted in the ground and almost invariably on a small hill. The cross in shape was usually the Latin Cross, but in some paintings it was the Tau Cross with the upper arm on the top of the long perpendicular arm. In some paintings the two thieves are upon crosses of this character with their arms over the top.

Most paintings of the crucifixion are merely pictorial representations of the event, either portrayed in the stiff conventional manner of the early painters, or in the more realistic manner of the later Renaissance artists. Some of them are baldly realistic and gruesome. But most of them, while picturing graphically the sadness and terribleness

of the tragic scene, do not make it repellent. Some of them possess an appealing beauty of color and rare mastery of drawing and an indescribable spiritual quality that distinguish them as artistic masterpieces.

Some of the early painters, however, possessed fantastic imaginations and painted crucifixions that are neither historic nor truthfully pictorial. Angels hover about the cross with flowing draperies and on the same canvas are cherubic heads with fluttering and crossed wings. Other paintings have angels with halos around their heads, as have the various persons grouped about the cross, some of whom are saints who were born and lived long after the time of Christ's crucifixion. Such pictures are allegorical and symbolic and not historic. A crucifixion by Perugino in the church of Saint Agostino in Siena is of this character. The Christ has a nimbus instead of a crown of thorns, and at the top of the cross is a pelican with wings extended and torn breast, with her young at her feet, symbolic of Christ's sacrifice. Two angels, holding chalices, are on either side and at the foot of the cross are Mary the mother of Christ, Mary Magdalene, and saints, and back of them is a lovely Italian landscape with Perugia on a distant hilltop.

There are other paintings of the crucifixion in various churches and museums that are not only allegorical but are curious examples of the remarkable realism of the thirteenth and fourteenth centuries. Angels and symbolic objects surround the attenuated figure of Christ, who is represented with blood flowing in streams from His wounds and caught in a chalice held by an angel, or a

female figure typifying the church. In some pictures Adam is holding the chalice. Tradition claims that he was buried on the very spot where the cross was erected. Groups of men and women are standing and kneeling near the cross, the saints, archbishops and art patrons are easily distinguished from the soldiers and other spectators by their halos.

The peculiar realism and historical inaccuracy of these early painters differs in kind only from some of the modernists. I recall a modern painting of the crucifixion, conventional in most respects, except that in the foreground in front of the three crosses is a howling, deriding mob, clad in present day garb. The meaning, obvious and suggestive, that we of the present generation by our lives and acts may reject and crucify Christ.

Another distinctive type of the crucifixion was made centuries ago. It has been called the Doctrinal Crucifixion, and is quite different from the historical. A notable example is in the San Marco monastery in Florence, painted by Fra Angelico, the monk who lived within its walls and decorated them with so many beautiful works of art. In him fervent religious faith and doctrinal teachings and beliefs were inextricably blended. It is exemplified in the fresco he painted. The figures on the crosses are similar to the conventional representation of most old masters. The group below the crosses contains not only the usual devoted followers, the mother of Christ, Mary Magdalene, Saint John the disciple, but Saint Peter, Saint John the Baptist with his cross, Saint Mark with his gospel, and various other saints, martyrs, and founders of religious

orders who lived some centuries later. Among them were both Dominicans and Franciscans, Saint Lawrence with his gridiron, Saint Jerome with his cardinal's cap, and Saint Dominic with a pen and book of the rules of the Dominic order, Saint Francis of Assisi bearing the marks of the stigmata, and others, with and without their symbols, surrounded by a symbolic border containing many portraits of saints and martyrs.

Not infrequently the cross was to be seen in paintings of scenes connected with the crucifixion, such as the procession from Jerusalem to Calvary in which Christ is shown bearing His cross and also walking beside it while it was carried by Simon of Cyrene. Another subject, a favorite with the early painters was the Descent from the Cross. In it Nicodemus and Joseph of Arimathea are usually shown as helping to take down the body of Christ from the cross.

In many old paintings God the Father is to be seen looking down from the clouds, with beneficent expression and hand extended in blessing. He is represented as a venerable man, with beard and robe, significant of the Scriptural statement that man was made in the image of God.

In the representations of the crucifixion in sacred art the Christ is pictured in both a realistic and idealistic manner. In some frescos and paintings the agony and ignominy of his death upon the cross is portrayed with graphic and often repellent realism. In some of the idealistic pictures Christ is represented as alive, with outstretched hands, and in all of them He has an expression of

peace and loving sympathy upon His countenance. They are suggestive of the mystery of religion and the spiritual meaning of redemption, through Christ's sacrifice.

In some old pictures Christ is represented, usually as a child, holding a globe surmounted by a cross, significant of His spiritual dominion over the earth. The covers of altar vessels for use in the communion occasionally have been made in similar shapes and old pewter and silver bénitiers or holy water fonts, have been found shaped to resemble a globe surmounted by the cross.

There were many curious crosses made centuries ago, some of which are still extant, that are peculiar examples of religious art. They are actual crosses of wood on which were painted representations of the crucifixion and on their extremities, made in the form of panels, are paintings depicting scenes in the life of Christ and portraits of various saints or the four Evangelists. Their portraits, or the symbols representing them, were frequently painted on very old crosses and later were reproduced in those made of metals. In the fifth century animals first appeared as the symbols of the Evangelists, and by the seventh century were used extensively as distinctive attributes— the Man for Saint Matthew, symbolic of the divine and human character of Christ, the Lion for Saint Mark, emblem of courage and strength, the Ox for Saint Luke, symbol of power and sacrifice, the Eagle for Saint John, typifying spiritual flight into the mysteries of divinity and eternity.

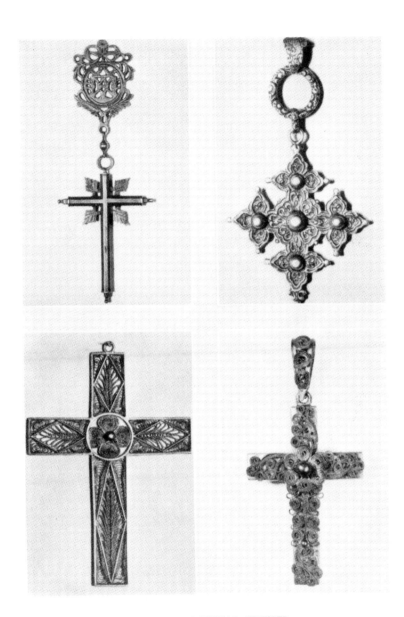

XIX. ORNAMENTAL CROSSES

ITALIAN—*Silver*
Elaborate Design Latin Cross
1850-1875

ITALIAN—*Silver*
Filigree Design
1850-1875

RUSSIAN—*Silver*
Elaborate Design Greek Cross
1800-1825

ITALIAN—*Gold*
Filigree Design
1800-1825

SAINTS OF THE CROSS

XX

IN religious art the saints have a very conspicuous place. Pictures of them and of events in their lives are innumerable in the churches, galleries, and museums of the Christian world. Some of these saints are pictured holding a cross or grouped near the cross in paintings of the crucifixion. Many of them have distinctive symbols that distinguish them from all others and by which they are easily recognized from the innumerable host of godly but otherwise unknown saints. These identifying accessories are exceedingly helpful. We always know Saint Peter by his key, Saint Mark by his lion and Saint Andrew by his cross. We might not always recognize Saint Cecelia if she were not invariably beside her organ, or Saint Catherine if she did not always have with her the wheel upon which she was to have been tortured but fortunately escaped by the intervention of angels.

Saint Sebastian is always stuck full of arrows and Saint Lawrence has with him his gridiron. The arrows and the gridiron are not only reminders of the disagreeable means by which these saints were removed from earth, but for these identifying attributes we might never recognize them.

Whenever we see a picture of a saintly man with his red hat and a skull on the ground beside him, we know he is Saint Jerome. Or the picture of a good-looking, saintly woman, with clasped hands and flowing robes, surrounded by many virgins, we are sure she is Saint Ursula. Just as we know that the picture of a grey bearded man in the desert resisting temptation in the form of an alluring, scantily dressed temptress, must be Saint Anthony.

It is a pity that the early painters often associated worthy saints and martyrs with things that might be distinctive but were often inappropriate and almost ludicrous. Saint Jerome was a learned doctor of great piety who lived in Rome in the fourth century. He renounced all for the life of a religious recluse and for more than thirty years devoted himself to translating and revising the Bible into the Latin tongue and writing many religious books.

Saint Ursula, who lived on the Rhine near Cologne, in the fifth century, devoted her life to the education and religious training of young women. The Huns came devasting the country and Ursula and all her young companions were massacred rather than submit themselves to the ruthless Huns.

Saint Anthony, who lived in Egypt in the third century, was one of the first hermits who lived alone in the desert. The temptations that beset him there were purely mental, conquered by his spiritual aspirations and devotions. The beautiful woman was no more a reality than the legendary devils that were reputed to have persecuted him.

Some saints are pictured with symbols or attributes that are possessed by others which is somewhat confusing, as in the case of Saint George and Saint Michael, favorite subjects of the old masters. Both of these saints are pictured as always slaying the dragon but have certain distinctive characteristics by which they may be recognized. Saint George, the warrior, always clad in armor, combating evil or material foes typifies the victory of Christianity over paganism. Saint Michael, the archangel, typifies fortitude in the combat against spiritual foes.

Saint George was a Christian soldier, living in the third century, who was persecuted and beheaded for his faith. His courage, loyalty, and high ideals endeared his memory all through the ages. He is the patron saint not only of England but also of other countries. Saint George is often pictured carrying a standard or banner, signifying victory. Other saints also are represented as carrying banners symbolizing victorious martyrdom, denoting that they were martyrs who had died for their faith.

There are two women saints, Saint Rosalia of Palermo, Sicily, and Saint Rosa of Lima, Peru, who are always pictured with roses scattered on the ground about them and with an angel about to crown each with a wreath of flowers. This similarity of symbolism makes it somewhat difficult to distinguish them. It is equally difficult to distinguish Saints Clementine and Henriette and other women saints, evidently of royal lineage, who are all equally good looking and clad in rich robes with crowns upon their heads and crosses in their hands.

There are also many militant saints, usually clad in armor and bearing banners with crosses upon them and crusaders' swords, that are equally difficult to identify. Some have halos and others crowns and ermine robes to distinguish them from other worthy warriors clad only in armor. Saint Louis, king and crusader, who lived in the thirteenth century and brought back with him to France from the Holy Land a portion of the true cross, is easily recognized from other warrior saints by the king's crown upon his head and the crown of thorns he carries in his hand.

There are countless unknown saints in religious art whose symbols have no individual significance. Many hold palms, to denote that they are martyrs. Others carry the cross, the symbol of their faith, and still others a model of a cathedral, indicating that they were the builders or donors of it. Unknown or forgotten they may be, but their halos distinguish them as men and women worthy to be called saints.

There was a curious conventionality about the art of the old masters by which it was always possible to know whether a saint had been made a saint before or after death by the shape of his halo. If while still living, the nimbus about his head was square; if canonized after death, the nimbus was round in form.

There were other conventional symbols or attributes that had particular significance. The Book, held by either the Evangelists or the Apostles signified the Gospel. If in the hands of a saint it was to signify that that particular saint was famous for learning.

The Lily, emblem of Purity, always present in pictures of the Annunciation, is also an emblem associated with Saint Francis, Saint Catherine, and some other saints, to emphasize the great purity of their lives.

The Staff and Gourd denote the Pilgrim, and saints who had gone on pilgrimages or who devoted their lives to helping the poor and the sick, journeying from place to place, are represented with a staff and gourd, or with the symbol of a shell. The staff was to help the pilgrim on his way, the gourd to carry water, and the shell from which to drink it.

The skull beside a saint denotes penance, and often appears in old paintings. The scourge is also to be seen in some pictures and indicates the saint inflicted penance upon himself with it.

The Lamp, the Lantern and the Taper are all symbolic of Piety or Wisdom, and were used as indicating the virtues or attainments of particular saints.

These symbols may be helpful in determining the special virtues and characteristics of the various saints, but are of little use in identifying them. It is far more satisfactory to recognize a saint at once by his distinctive personal symbol. Saint Peter is always known by his key and even more assuredly if there is a cock beside him. Saint Paul by the sword he holds—the sword of the spirit—Saint John, the disciple, by the chalice or sacramental cup he carries in his hand, which symbolizes Faith.

The more one investigates the connection between saints and their symbols the more perplexing but interesting the subject becomes. My own particular interest

was aroused by a collection I made some years ago of rare old lithographs and prints of various saints. These pictures possess little merit artistically but illustrate most realistically the association between saint and symbol. They are almost as graphic as that gruesome statue in the cathedral in Milan of a saint who was flayed alive and is placidly holding his own skin in his hands.

In this day and generation it seems unnatural and archaic to associate visible, often ludicrous, symbols with persons worthy of sainthood. No one doubts that these saints once lived and suffered persecution and even death because of their faith. There are saints today, not known or pictured with crown and palm, who suffer and sacrifice and are as devoted followers of the cross as those who centuries ago were enrolled as saints.

MARTYRS OF THE CROSS

XXI

THE early Christians were just as human as those of today and not so very different. They often strayed, as we are apt to do, from the straight and narrow path. They also had confused ideas about Christ's mission and His teachings. All through the ages men have stumbled and blundered in their beliefs. That which was accepted by one generation as vital and essential truth was rejected by the next. The simplest truths have often been obscured by dogma and doctrine.

There was one commendable thing about those early Christians and many who came after them, they were willing to die for their convictions. Torture and death were endured bravely and uncomplainingly for their faith. And so it was there came to be martyred saints to whom after their martyrdom men and women appealed for help in distress or for particular blessings.

Many of these martyrs were either men or women of high birth or great learning, whose sufferings and sacrifice endeared them to the masses. Because of their virtues and faith in life, and courage and fortitude in persecution and death they became popular heroes and were enrolled among the saints.

In the first centuries of the Christian era the saints were not numerous, but they multiplied greatly as their popularity and usefulness increased. Their pious lives and glorious deaths were believed to fit them particularly as intercessors of the Diety. Special saints were thought to be of particular use for definite needs and were besought for help in sickness or disaster, or as intercessors for special blessings.

Saint Anthony of Padua, who was greatly beloved by the poor and the sick, was believed to have power to restore health. He was also helpful in the recovery of lost articles, and was thought to be in some mysterious way of special use and help in obtaining desired offspring. To-day women and children throng about the altar in the great cathedral in Padua beneath which he is buried, and lay their hands upon his tomb and devoutly pray.

Saint Appollonia of Alexandria was supposed to be most efficacious in relieving the toothache. For ages past her aid has been sought by those suffering that affliction. She was a Christian martyr, persecuted by having her teeth knocked out before she was burned to death. Her symbol is an antiquated tooth extractor.

Other saints were renowned for help and relief from painful maladies of every kind. Still others were esteemed as necessary and important intercessors for various desired blessings.

The more the idea of saints as intercessors grew, the more the saints increased in number. Every town had its patron saint and nearly every church its particular favorite. Many saints had symbols that were significant of their

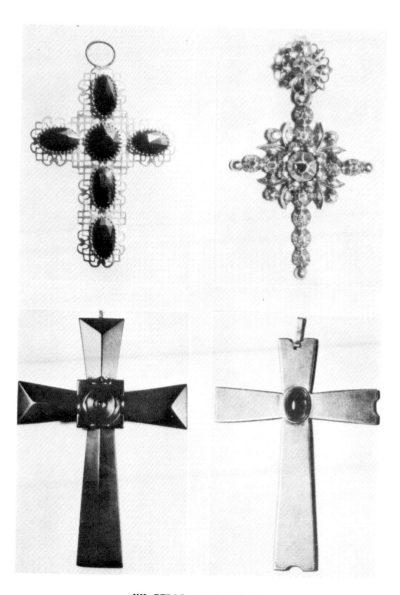

XX. PERSONAL CROSSES

Spanish—*Gold and Garnets*
Open Work Design
1725-1750

English—*Whitby Jet*
Geometrical Design
1825-1850

Belgian—*Silver and Diamonds*
Applied Ornamental Design
1675-1700

American—*Silver and Amethyst*
Conventional Design
1875-1890

virtues or denoted the particular thing they had done that won them eternal honor and distinction. By their symbols many saints are recognized and remembered by the ignorant or indifferent beholder of their portraits, when other saints, equally pious and saintly, with only a halo and no distinguishing symbols are unknown and forgotten. This association of saint and symbol in religious art is extremely helpful. In the churches and galleries of the old world are numerous serene, sweet-faced women saints and countless serene, smooth-faced and bewhiskered men saints who are never known by the chance passer-by, who confidently recognizes those who carry about with them their symbolic attributes.

Saint Eustace is one of these. He was among the earliest of the martyrs and was converted by the miraculous vision of a cross between the antlers of a stag he was about to kill in the chase. His devotion to the Christian faith caused him to lose his property, his family, and his life. Saint Eustace is always represented accompanied by a stag with a cross between his antlers. One never confuses him with any other saint.

Saint Agnes is always known by a platter she carries, on which are human eyes. According to tradition Saint Agnes, when a very young girl, became a Christian and refused to worship and offer incense at the altar of Minerva in Rome. She was imprisoned and tortured and stripped of her garments and compelled to stand naked in the street. Because of her faith and innocence the eyes of the pagan crowd were all miraculously turned away, except one young man who continued to gaze upon her till

a flash of light struck him blind. It is his eyes she bears upon the platter in the many pictures of this gentle, innocent girl who was beheaded because of her faith.

In an old print of Saint Stephen, the first Christian martyr, the symbolism is perhaps less obvious but suggestive. Saint Stephen was stoned to death and in the picture he is represented as seated upon a pile of rocks holding a martyr's palm.

In some old paintings and engravings the martyr is portrayed actually enduring martyrdom, with all its revolting and unpleasant details. A suggestive symbolism is preferable and was used much more often in old pictures. If the saint was beheaded he was usually represented standing near the block, serene and untroubled, with the executioner in the background with broad ax or sword in hand. If the saint was burned to death he was portrayed placid and unconcerned beside a pile of faggots or smoldering fire.

In other old pictures there is a more realistic touch. The saint is in the foreground peacefully praying or preaching, and in the background he is being actually tortured, beheaded or in some other way put to death.

In some old prints certain women saints are pictured with a curious combination of truthful fidelity and symbolic imagery.

Saint Susannah, a virgin of the third century, who was martyred because she was a Christian and refused to marry, is represented kneeling and beholding in a rapt vision, angels, one of whom is giving her a martyr's palm. On the ground beside her is a chain and a sword, symbols

of her imprisonment and death, and before her lies a cross.

Another Christian martyr was Saint Christina, daughter of a Roman magistrate, who possessed many golden idols. She had these destroyed and distributed the pieces among the poor, which so incensed her father he had her thrown into a dungeon and tortured in various inhuman ways. Her flesh was lacerated and she was cast into a fiery furnace and into a lake with a millstone tied about her neck. She survived all persecutions to die at last, pierced by arrows. She is pictured serene and untroubled, holding a palm in one hand and arrows in the other, with a large millstone attached by a rope around her neck.

Another virgin martyr was Saint Eulalia, who lived and suffered when the Emperor Diocletian decreed his bloody edicts against the Christians. She is shown in an old print surrounded by the instruments of torture with which she was persecuted and burned to death. She kneels with calm, undisturbed countenance upon her pyre. The martyr's palm and chaplet of flowers are just within reach. In the background men are erecting a wooden cross, typifying her sacrifice and martyrdom.

These are only a few of the countless number of martyrs who lived and suffered and died in the centuries that have come and gone since Christ was martyred upon the cross. To them the cross was not merely the symbol of their faith, but of their sacrificial devotion. In religious art it was frequently an accessory. The martyr either held a cross in his hand or one was upon an altar beside him, or appeared somewhere in the picture, either as a wayside cross or as a decorative or pendant cross upon his person

or garments. If the saint was a king or noble his crown is surmounted by a cross. If he was a crusader he bears a banner with a cross upon it and upon its staff another cross. Women saints are often pictured wearing ornamental crosses and beside them an Altar or Pendant Cross. The saint and martyr is fittingly portrayed with the cross symbol. The cross is not only the emblem of Christ, the greatest of the martyrs, but symbolizes service, sacrifice, and salvation.

Saint Christopher was a favorite saint with the old painters. I remember well one day descending a rather unfrequented stairway in the Ducal palace in Venice and seeing a painting by Titian of this Saint with the Christ Child in his arms. There is an old legend that Saint Christopher, who was of gigantic size and repellent aspect, determined to serve only the king who was the greatest on earth. He sought for this sovereign far and wide and when he believed he had found him offered to become his follower. The king gladly accepted his allegiance, but when Christopher discovered that the king always made the sign of the cross whenever the name of the devil was mentioned, he refused to serve him and set out to find the devil whom the king feared. Contrary to the old belief that one can easily "go to the devil," Christopher had a long search before he found him and became his follower. One day as they journeyed about upon the earth, they came to a wayside cross and the devil trembled and would not pass it. Then Christopher renounced Satan for he perceived that there must be a king more powerful and him he sought to serve. In his wanderings he came upon a

holy hermit who told him of Christ, his Master, whom he must serve faithfully without seeing and obey all His commands, and that he must often fast and pray. Christopher told the hermit he could not fast lest he lose his strength and he could not pray because he knew no prayers. Then the hermit told him if he could neither fast nor pray he could become a follower of the Master by serving others, and sent him to a river wide and deep, where many travelers who tried to ford it were drowned. He bade him to tarry beside the stream and carry over the wayfarers, and because he was of colossal size and great strength, Christopher gladly accepted the task and dwelt beside the turbulent river. He uprooted a tall palm tree for a staff and ever after, all his life, failed not to aid the weary traveler and to carry the weak and fearing ones across the stream. The Lord in heaven looked upon him with favor and saith: "This strong man knoweth not the way to worship Me, yet he hath found the way to serve Me."

One dark night when asleep in his hut, he heard the voice of a little child beseeching him to carry him across. He put the child upon his shoulder and, taking his palm staff in his hand, waded into the stream. The wind blew furiously and the waves almost overcame him, and the weight of the child he bore grew heavier and heavier. When he reached the farther bank, he fell exhausted on the ground and exclaimed, "Who art thou, child? Had I carried the whole world upon my shoulders the burden had not been heavier."

And the child replied: "Wonder not, Christopher, for

thou hast not only borne the world but Him who created it." Christopher worshipped the Christ Child and journeyed forth throughout the land ever helping persecuted and afflicted Christians.

A heathen monarch had him seized, tortured, and beheaded, and he became a martyr because of his faith and service to others. He is always pictured carrying the Christ Child.

In my collection of old lithographs and engravings of various saints and their symbols, some of which I have described, is the reprint of a wood engraving which is in the British Museum. It is the earliest known example of printing and is dated 1423. It is a crude but realistic representation of Saint Christopher wading a turbulent stream, bearing a huge palm tree laden with fruit, with the Christ Child upon his shoulders. One hand of the Child is extended in the sign of the cross and the other bears aloft an orb or globe surmounted by a cross signifying Christ's sovereignty over the earth.

The unadorned cross on the orb or globe was frequently used on coins, crowns and in religious art in paintings and stained glass, but seldom the crucifix on the orb. I have one such on the top of an old French pewter bénitier and another one of silver that once was on an old Italian altar communion vessel. (Page 166).

On the campus of Rollins College in that charming town of Winter Park, Florida, amid moss laden trees and tropical foliage and flowers is an exquisite chapel of Mediterranean architecture. It is of rare beauty, reminiscent of the past, with cloistered garden and towering

spire surmounted by a gilded cross that gleams brightly in the brilliant southern sunshine. It is a memorial chapel, dedicated to a creedless worship of God.

I was present at the impressive occasion of the unveiling of a beautiful stained glass rose window. It is symbolic of wisdom in all branches of learning. Above all the figures and symbols that typify the importance of knowledge is the Christian Cross surmounting an orb signifying the value above all of spiritual knowledge.

CURIOUS USES OF THE CROSS

XXII

ISTORY and literature record many interesting facts and incidents of strange uses and curious customs connected with the cross.

Christmas, Christ's birthday, is often written and printed, Xmas. The association of the Savior with the cross is obvious and logical. There are numerous instances, however, where the use of the cross is either strangely inappropriate or utterly inconsistent.

There is a legend that in ancient times nearly every house in Alexandria had painted or carved upon it a cross. Whatever was the cause of this general adoption of the symbol, or its later abandonment, is unknown.

Crosses, at one time, by the command of the Emperor Constantine, were erected in the principal streets and squares of Rome and Constantinople and later disappeared, and their use so completely abandoned that it took an ecclesiastical decree to restore them to church altars.

The early Christians used the cross symbol infrequently, but there is a tradition that they revealed themselves to fellow Christians by making the sign of the cross in the dust of the roadway with staff or sandal, and

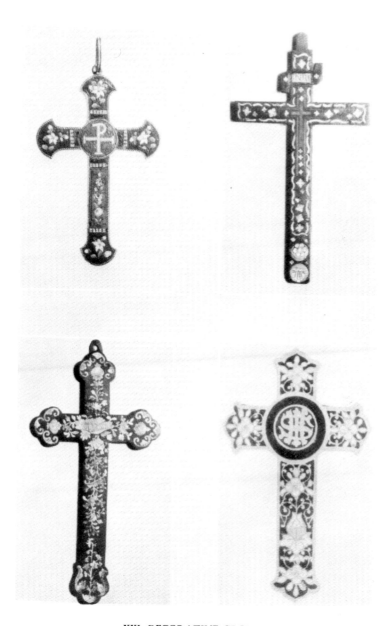

XXI. DECORATIVE CROSSES

ITALIAN—*Mosaic*
Flower Design with Labarum Cross
1850-1875

FRENCH—*Pearl and Wood*
Ornate Flower Design
1800-1825

ITALIAN—*Pearl and Wood*
with Inlaid Cross
1775-1800

FRENCH—*Limoges Enamel*
Ornamental Design with Entwined
Letters I H S
1750-1775

then quickly obliterating it fearing recognition.

In the baths of Diocletian in Rome there have been found bricks bearing the impress of a cross. Thousands of Christians were persecuted and forced by the Emperor Diocletian to build his famous baths, and it might have been as a petty protest against the cruelty and persecution of the pagan ruler that they made some bricks bearing the Christian symbol.

All through the ages homes have been protected for one strange reason or another by the cross symbol. On the eve of St. Bartholomew the houses of all Catholics were marked with a cross upon their portals and the Hugenots, whose homes were not thus protected, were massacred.

For quite another reason, only a few years ago, thousands of Filipinos marked the front doors of their homes with white crosses. The cause for so doing was a superstitious belief that three black robed, headless sisters, known as the Tatlong Marias—the Three Marys—were abroad in the land and came at night and knocked upon the doors of many houses. Whoever answered the knock was stricken with a fatal illness. Protection from this dire calamity was believed to be assured by drawing in chalk, or painting upon the door, a white cross.

It was a custom in early times to bury all persons who for any reason were not considered worthy of burial in consecrated ground at the crossroads outside of the town. Always there stood beside the public road a cross and at its foot was piously buried the unworthy one who was excluded from the burial place of those who were believed to be more worthy.

Another rather curious old-time custom was to bury a cross of silver or metal with the deceased to protect him from evil spirits. It might have been intended as an evidence of his piety and faith that occasionally the gospels, as well as a cross, was laid upon his breast and interred with his body.

Curious as these customs may seem to us, many things we do possibly will seem to be as strange and unaccountable a few generations hence. We try to dictate to our young the way they should go, even as we seek to train them in their table manners, forgetting or not knowing that in the olden times monks were first of all taught obedience and then at the end of their frugal repast to always piously lay the fork crosswise on the knife that it might thus represent the cross.

From time immemorial hot-cross buns have been associated with Good Friday. They are still quite universally used, crisp rolls or buns marked by an X cross. They have now little significance but long ago people believed that the hot-cross bun was consecrated bread that would never grow mouldy and that it would ward off witches, cure some diseases and protect from fire and other misfortunes.

The custom of placing the sign of the cross on deeds and wills and documents dates from medieval times and is still accepted to this day as an oath in place of a signature on legal documents by illiterate persons who cannot write.

During the Middle Ages both French and Spanish sovereigns signed official grants and decrees by a roughly

drawn cross. Even nowadays some people assert the truth of a statement by the old-time phrase and gesture, "Cross my heart."

During the reign of Charlemagne, lawsuits were decided sometimes in a very peculiar way. The plaintiff and the defendant were required to stand in court and to cross their arms upon their breasts and the one who held out the longest won the case,—a somewhat antiquated method according to modern legal ethics but possibly as good a chance of obtaining justice as by the verdict of an ignorant jury. To this day choir boys in European cities stand when singing with crossed arms.

Sir Walter Scott tells in graphic verse how in Scotland in the far-off days of the minstrels when clan fought against clan, they were summoned to war by a fiery cross. On a rugged mountain close beside a lonely loch the chieftain with broadsword in hand waited impatiently while his vassals prepared the ritual fraught with dire and deathful meaning when the cross of fire was sent forth upon its mission of calling the clansmen to war. A barefooted hermit, in a rough woven robe and hood, stood beside a heap of withered boughs kindling them into flames. He seemed more like some ancient druid than a Christian priest as he mixed the charms, uttering prayers and strange incantations. A goat, the patriarch of the flock, was slain by the chieftain's blade and laid beside the burning pile. The hermit monk formed a slender cross, a cubit in length, of branches from a yew tree and with muttered curse of woe and wrath to all traitorous clansmen set fire to the cross and holding it on high proclaimed

the infamy and dreadful fate of all clansmen who failed to fight when bidden. Then the chieftain took the burning cross and extinguished it in the blood of the goat and gave it to his fleetest henchman to carry from hut to hut as a command to go forth to battle. A strange symbol with which to summon men to war!

Stranger still that this weird ceremonial of the past should have been repeated in our own time and country. The terrible conditions that prevailed in the conquered South after the Civil War produced a spectacular up-rising. It was a crusade against rank injustice and lawless crime. The country was ruled by corrupt politicians and ignorant negroes. There resulted an orgy of crime and political tyranny. Men were robbed and killed; women were insulted and outraged; property was burned and destroyed. To war against these lawless conditions the Ku Klux Klan was organized. It was a secret band composed of men of position and property. They met secretly at night and with mystic rites and solemn oaths pledged themselves to punish the guilty and to restore law and justice in the land.

The klansmen of the South were summoned as were the clansmen of Scotland. A few faithful followers met in a cave or dense wood and with prayer and mystic cere-monies the leader fastened two small pieces of wood in the form of a cross and ignited it. Then holding it up as a pledge before them extinguished it in the blood of a vic-tim mingled with water and a trusted courier rode far and fast to distant places carrying with him the symbol that was to summon the klansmen. The next night they

gathered in some lonely spot in the mountains, each man armed and mounted upon his horse, a ghostly figure in his white robe and masked head covering. All were dressed alike and undistinguishable. Their steeds were concealed beneath a white disguise. On the front of each horse was a scarlet circle with a white cross and on the flanks the three red mystic letters, K. K. K. Every man of the intrepid band bore upon his breast a scarlet circle with the white cross, the symbol of peace and sacrifice, and rode forth upon a mission of war and bloodshed. Sometimes upon a hilltop, they raised a fiery cross as a signal or a warning. The need for such a strange use of the cross has long ago passed.

In the Southland another curious custom still exists. Once a year on the feast of Epiphany, is the blessing of God invoked upon the waters of the earth. It is a custom that has long prevailed in many places in the old world. It is also performed with traditional ceremony strangely intermingled with modernized additions in the little seaport of Tarpon Springs, Florida. This town is the home of the divers and fishermen who go on long voyages in far southern waters and bring back cargoes of sponges in their brightly painted ships. They are the descendants of the ancient Greek seamen who sailed the Aegean sea long ages ago.

At the ceremony of the Blessing of the Waters, thousands of spectators gather to watch the interesting spectacle. In the sheltered harbor are many of the little gaudily colored ships of the sponge fishermen, decorated with flags and festoons of sponges. In the little church of St. Nicholas nearby a religious service is held and the

chants of the Greek orthodox liturgy are heard, and a solemn procession comes out of the church door. Priests and acolytes with censers and banners led by the Archbishop, a venerable prelate clad in rich vestments bearing his crosier. Then follows a motley throng of the sailors and their families in the bright colored costumes of their fatherland, with a band playing a jazzy march.

The incongruous procession reaches the shore and the patriarch and attending priests stand upon the deck of an elaborately decorated ship. The ancient ritual of the Blessing of the Waters is pronounced while white doves are released and flutter above. As the ceremony ends the Archbishop raises above his head a shining cross and casts it into the sea. Instantly a group of tense, waiting divers plunge into the sparkling waters and before the cross can reach the bottom one of them rescues it and carries it in triumph ashore. At night he goes from door to door all through the town and receives gifts of money which afterwards is distributed among the families of divers who have lost their lives in their dangerous occupation. To the victor is the promised assurance of safety and success in his hazardous career and blessings upon all who venture forth for sponges upon the vast waters of the sea.

UNUSUAL CROSSES

XXIII

A LITTLE way beyond the ancient fortress and gates of St. Augustine, the oldest city in our land, is the fabled Fountain of Youth. Centuries ago Ponce de Leon, the Spanish adventurer and explorer, sought this spring to drink of its waters, hoping and believing thereby to restore his lost youth. His quest was in vain but at the end of his voyage he discovered and took possession of a new land which he named Florida.

It strangely happened that on the very day of the week and the month some four hundred years and more after Ponce de Leon landed on the Florida shore I sought as he did the Fountain of Youth and drank of its refreshing but unrestoring waters. It was a quiet, restful hour. No other visitors were at the historic shrine, almost unchanged in the centuries that had passed, except for the coquina walls enclosing the fountain and the little chapel built of native stones on the site of the first Christian mission in America.

I could see the very place on the nearby shore where Ponce de Leon is said to have landed and could almost visualize his picturesque high-pooped vessel, casting anchor in the inlet just beyond. According to tradition

he was guided by friendly Indians who had told him of the mysterious Fountain of Youth. Beside it, he ordered to be laid in the earth a reclining cross of stones, fifteen stones laid east and west, and thirteen stones laid north and south, indicating the year 1513 when he landed and took possession of Florida. For by the decree of the King of Spain with every discovery of new lands that was taken possession of for him, such a landmark must be placed; and the cross was planted and blessed, for by this symbol it was to be known as a Christian land. At the ceremony of the placing of this cross a prayer was offered that "the name of the Lord Almighty and Everlasting God be known and proclaimed in these new regions of the world." This was the same prayer with which the cross of Columbus was carried into the new world. The cross of stones beside the Fountain of Youth is still there, an unusual cross of great significance.

In Sicily it has been the custom for centuries to decorate the little donkey carts, that are everywhere to be seen, with paintings of religious and historical scenes and personages. The wood of which they are made is hand carved in all exposed parts and every plain surface is covered with bright, colorful pictures. In Taromina, that beautiful, fascinating city with a past, remote and unique, are to be bought many and varied antique treasures. I found some old crosses and a wooden panel from the side of an old donkey cart. The painting upon it is dim and faded. It was painted more than a hundred years ago. It depicts Christopher Columbus taking possession of the new world he had discovered. In the center of the picture Columbus

XXII. CURIOUS CROSSES

Sicilian—*Ivory, Tortoise Shell*
Unusual Cross Design
1750-1775

Gaelic—*Stone*
Ancient Celtic Design
1850-1875

Italian—*Bronze*
Early Design
1800-1825

Irish—*Bog Oak*
Crudely Carved Design
1825-1850

is standing, very much dressed up, in a flowing mantle, fur edged tunic and a hat with a waving plume. In his hand is a banner and back of him are his followers, some of whom are in armor. He appears to be addressing an Indian chieftain, in an elaborate, feathered headdress, surrounded by his braves. There are so many of them that they are represented in a background of four tiers of heads. Before Columbus is a large wooden cross supported by a monk and a soldier, who kneel on each side of it. The cross is plain and unadorned except that on one side is the Spanish crest. The picture is a curious combination of realism and historic inaccuracy; of value as illustrating the ceremonious act of taking possession of a new land for king and God and the important part the cross always filled in such ceremony.

In Sicily I found several unusual crosses which are interesting because so out of the ordinary. A very old one was an altar crucifix carved out of a single piece of wood, very crude, probably made by a peasant for the altar of a village church in the remote interior of Sicily. The garb of the Christ is Byzantine in appearance. The arms are straight and unnatural, the feet crossed and beneath them a man's head, probably intended for Adam's. Below it is a cross with two intersecting hands and arms. On the base is a realistic representation of St. Peter crucified upside down as he considered himself unworthy to die like his Master. A remarkable figure with wings, perhaps intended for an angel, is beside Peter. Over the head of the Christ is a tablet with the familiar letters INRI and on his breast another bearing the letters IHS surrounded by rays

of glory. The peasant who carved this cross, so crude and inartistic, could not make a statue but the religious spirit within him found expression in the carving of the cross. (Page 166).

Another crucifix I obtained in Sicily was in every re- spect the opposite of this one. It is of a high order of artistic craftsmanship. It is probably of Florentine, rather than Sicilian origin. It is unusual because of the materials of which it is made, tortoise shell, mounted on a large size wooden cross. The figure of the Christ is of ivory, exquisitely carved, conventional in details and position. The beauty and dignity of the figure is unusual and notice- able. It was probably made during the latter part of the 18th century. (Page 186).

A simple but rather unusual altar cross of Sicilian make is the plain Latin Cross of wood with a conventional diamond design inlaid in ivory and tortoise shell, made probably about the middle of the 18th century. (Page 150).

I found also in Sicily a cross that has the appearance of being of Spanish origin. It is a large pendant crucifix of ivory elaborately carved. The terminations of the arms are floriated but of most unusual design. The figure of Christ is quite attenuated with very prominent ribs and a peculiar loin cloth and the head has a crown of glory instead of thorns with an unusual nimbus behind it. The entire cross is outlined in a perforated border. It is altogether a rare design, made probably early in the 18th century. (Page 174).

Another unusual cross I found in Switzerland. It is a rather small pendant crucifix containing some sacred

relic concealed in the bottom. It is crudely carved out of a single piece of wood and was perhaps made by some peasant far up on a mountain watching his grazing cattle. Below the figure of the Christ stands the Virgin with head covered and voluminous robe. Her arms are crossed and behind her is the sword of the spirit with which her heart was pierced. (Page 78).

There are many crosses even more unusual than these that can be found in unexpected places. Some of them are almost grotesque in appearance. The simple, unornamented cross, with its impressive historic and spiritual associa-tions has been often made in fanciful forms and over adorned with fantastic symbols utterly devoid of artistic merit or significant meaning. These artistically inade-quate creations are of little help to higher thoughts.

In an old graveyard in Biloxi on the Gulf of Mexico, is a rough hewn slab of wood that marks the grave and is sacred to the memory of some good woman. Surmounting it are three crudely carved crosses. One alone would have been adequate testimonial of her piety and goodness; a multiplicity of them was as futile and confusing as some of the incongruous symbols on many old crosses. Men have always cluttered fundamental truths with non-essential ideas and sentiments.

Many crosses are unusual, not in design, but because they are commemorative of noted people or historic events.

Within the ramparts of the old fort on the bank of the Niagara river stands a commemorative cross. It is neither old nor unusual, but it commemorates a strange event in the stirring history of the Niagara frontier.

The cross and its setting is a wonderful picture of the past. I felt as I walked over the drawbridge, through the portcullis and stood within the ramparts of Fort Niagara that the present was strangely and mysteriously linked with the past. The cross loomed high before me against a beautiful cloudless sky, its dark outlines intensified by the blue waters of Lake Ontario. Near by were two wind-blown, misshapen trees that had withstood the storms of nearly two hundred winters. Across the wide, swiftly flowing river was the wooded Canadian shore. It was all unchanged: the sky, the lake, the river and the green banks looked much as they did three centuries ago when the brave discoverers and devoted missionaries came in their frail canoes from Quebec.

On the high bank where river and lake meet the French built a stone fortress that has stood there for more than two hundred years. Three flags, the French, the English and the American, have surmounted its frowning walls. Recently, it has been completely restored from the original plans and refurnished within with furnishings, both old and reproductions, that visualize the time of its occupation by a French garrison, and show the alterations made when it became an English fort and Indian trading post. Its outer walls have stood unchanged for more than two centuries.

Long before it was built a log fort stood on its site and a hundred soldiers were quartered there in the winter of the famine in 1688. Without sufficient food, constantly menaced by hostile Indians, and plague stricken, most of the ill-fated garrison died before spring came and supplies were received. With the relief party was Father Pierre

Milet, a Jesuit missionary to the Iroquois Indians.

As a thank offering for the preservation of those who survived, the priest had a great cross hewn from an oak tree and erected in the midst of the soldiers' graves, close beside the fort.

When the fort was abandoned a few months later, and for long years afterward, that rough wooden cross stood a visible reminder of the tragic event.

Three centuries later on the very spot where stood the cross of Father Milet was erected the present cross to his memory. It is not only a memorial to him, but it should commemorate the sacrifices and the sufferings of many early missionaries in their unsuccessful efforts to convert the Indians to Christianity. They believed that the missionaries were magicians and sorcerers who had come to do them evil. Among these early missionaries was Father Brébeuf, who claimed with joy that he saw a luminous cross at night in the heavens which to him was a sign of his martyrdom. Another missionary, Father Hennepin was the first one to write and publish a description of the great cataract of Niagara.

Always there came with the explorers and the settlers to this region, the missionaries. They journeyed far, paddling up the swift river, over the portage around the Falls and into the unexplored wilderness beyond. It was not gold the missionaries sought nor lands, but to bring to the Indians the Christian faith.

LaSalle and other brave explorers tarried at the old log fort on their voyages of discovery to the Great Lakes in the West and the unknown rivers in the South, and with

them always went the missionaries of the cross, who cared for the sick, comforted the dying and blessed the crosses that were always raised wherever unknown lands were discovered and conquered. They were cross bearers.

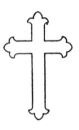

IN QUEST OF CROSSES

XXIV

THERE is little opportunity either to see or acquire old crosses in our country. Even in museums, the storehouses of all kinds of relics of the past, crosses are rarely to be seen and a comparative study of them almost impossible. Our museums are filled with the swords of famous generals, the garments and other personal belongings of both distinguished and humble folk, and countless other relics of every conceivable sort, except crosses.

Doubtless the natural human desire to possess what is difficult to obtain was one reason that led me to collect crosses. The variety and beauty of them was a stimulating incentive and my search has never ceased. I have often been asked how and where I found the crosses I have collected. It is a tale far too long and uninteresting. But to recount a few experiences in my quest is to reveal somewhat the joy and satisfaction of the collector, for collecting is not merely acquiring. It is increasing and broadening one's knowledge about many things and has no end of unexciting but pleasurable adventures in the pursuit.

Of all things to collect, old crosses are about the most

elusive and difficult to find. The quest leads into strange, unknown paths, as they are rarely to be found in the accustomed marts.

Antiques of all kinds are everywhere to be found, either in antique or secondhand shops and auction rooms. There is an almost unlimited choice and supply of them. Fragile old glass and china, a marvelous survival of the vicissitudes of time; antique furniture, more or less the worse for wear, that has outlasted generations; family heirlooms in silver and pewter, their luster a little dimmed. All of these are comparatively easy to obtain for the seeking and the price, but not so with old crosses. They are more revered possessions and seldom are offered for sale.

My search has taken me far and wide. I have rarely found old crosses in this country and even in Europe they are scarce. I have sought for them in innumerable curio and antique shops in various cities and often many weeks would pass without finding a single one. It is a waste of time looking in most antique shops, as useless as hunting for jungle beasts on cultivated garden slopes.

There are other handicaps to the quest for old crosses. Most antique dealers know nothing about them, nor can give any reliable information as when and where they were made. Usually they get both centuries and countries sadly muddled. The collector must possess a knowledge of such matters and of values and characteristics of workmanship or he is likely to be deceived.

Personally, I had much difficulty owing to my linguistic limitations. My halting inquiry, in mispronounced Italian,

XXIII. RARE CROSSES

Russian—*Brass*
God the Father with Angels
Saints and Skull in Tomb
1700-1725

Russian—*Silver*
Oriental Ornamentation
Superimposed Cross
1750-1775

Balkan—*Silver*
Cross Outlined within
Elaborate Border
1725-1750

Coptic Cross—*Bronze*
Early Type Greek Cross
Simple Incised Ornamentation
10th Century

for an "antico croce" was liable to produce anything antique but a cross, and the simple query, "quanto costo?" always resulted in a voluble torrent of unintelligible words that had to be translated into written figures. Then came the inevitable bartering with much vociferous gesticulation.

I have had many interesting experiences in my search for old crosses. To tell a few of them will illustrate the intricacies and diversions of my long continued quest that has taken years and led me to many foreign countries into quaint old cities and queer little towns, and added zest and keen enjoyment to my travels.

During a long stay in Venice, a chance acquaintance, a cultured English woman, was my valued guide in that fascinating city. She had lived there for a long while and was an enthusiastic lover of Venice, with a mind stored full of its history, lore and art. She knew and felt the beauty and charm of the old city with its crumbling, colorful buildings, and gems of architecture, paintings and sculpture. She knew her Ruskin as she did her prayer book, and led me to places he described and to other favorite haunts of her own, far away from the Grand Canal, through narrow, alley-like streets not much wider than a doorway, out upon some unfrequented piazza, dominated by some ancient church of huge proportions and Byzantine beauty or Baroque ugliness within which was some painting or statue or carving worthy our study and admiration.

On other days we would thread our way through little

winding streets, off from the Rialto, through devious ways and over many bridges, guided by a troop of persistent children or an undesirable beggar, none of whom were ever satisfied with the tips we gave for their unsolicited services. Suddenly, we would come upon some historic shrine or an old palace, to which we had entrance through the lower rooms where the gondolas were always stored, on up marble steps to the spacious apartments where gathered the Venetian nobility in the days of the doges.

Everywhere on these rambles, I led my companion into many antiquity shops; always seeking, seldom finding an old cross. Finally, weary of tramping many miles, we would seek the solace of a cup of tea and my English friend was happy and I somewhat consoled even if my search for a cross had been unavailing.

We always walked on these quests. We would not have found the few old crosses I secured, or have seen the many artistic treasures of the past had we lolled luxuriously in a gondola doing the famous stock sights of Venice.

By a fortunate chance one day, in an almost deserted piazza beside a crumbling old church, its niches filled with broken statues of forgotten saints, was a small antiquity shop. In front of it hung a silver sanctuary lamp and upon the stone pavement were several carved wooden and gilded church ornaments and an altar crucifix of unusual and artistic craftsmanship. Its base was of ebony; the Christ figure of bronze and the ornamental portions of brass and silver. It was of Italian workmanship made about the middle of the 17th century. It took two or three

interviews and much persuasion before a satisfactory price was agreed upon and I became its possessor. (Page 46).

I chanced to wander one day through a narrow, unknown street, crowded by men and women who spend their days out of doors gossiping, making lace, sewing the bright colored sails that stretch across the roadway and cooking spaghetti over charcoal braziers. To escape the chattering jostling crowd, I entered a little shop where were made and sold gilded and painted boxes, trays and other decorative things. On a bracket I discovered an old Italian cross, different from any I had ever seen. It was of mother-of-pearl with fourteen holes representing the stations of the cross. It stood upon a roughly carved dark wood base suggesting rocks and intended to represent Calvary. It probably was made early in the 18th century. After some persuasion I convinced the shopkeeper it was out of place among his modern wares and carried it away with me. (Page 166).

Florence, the treasure-trove of medieval art, has always a great fascination for every lover of the beautiful, with its many timeworn churches filled with colorful frescoes and mosaics and interesting museums and ancient palaces that contain so many fascinating art treasures.

In the churches and museums of Florence are more crosses than are to be seen in any other Italian city. There are also more of them for sale in the shops. There I found some interesting old rosaries that are kin to crosses.

One antiquarian, whose shop I often frequented, seemed to specialize in them. I could not resist a few,

attracted by the beauty of the beads and the curious little crosses and religious medals of silver and bronze hanging from them.

Perhaps I should have resisted for I became so much interested that I have since collected many old rosaries, medals and coins, particularly those having crosses upon them.

I have quite a variety of old rosaries. Some of the beads are made of semi-precious stones, others of colorful Venetian glass, and crystals, metals, seeds, pottery and wood. They are most of them more than a hundred years old. An unusual and interesting one is of crudely cut amber beads—the rare, brownish amber that is said to derive its peculiar color from being immersed in the ocean for many years, perhaps centuries. Another very curious rosary, probably about one hundred and fifty years old, came from Mexico. It must have hung at one time on the wall of some old chapel. It is so large and long it never could have been carried about. The beads of carved wood are as large as walnuts and the unusual bronze crucifix of corresponding size. Attached to it is a dim old Spanish picture of a woman saint painted on a copper plaque.

Many of the crosses I discovered in Florence I do not possess. They were precious metal and jeweled crosses of rare workmanship and the prices asked for them were beyond the limits of my purse. It was not the only time or place my desires have been balked for a similar reason. They were for me as unattainable as that beautiful cross made by Cellini that is clasped in the hand of the Archbishop Borromeo, who died more than three centuries

ago and lies exposed, a most unpleasant spectacle, in his silver and crystal casket, in the great cathedral at Milan. In the realm of collecting, as in most of life's experiences, it is not possible to get all one wants and perhaps that is not altogether undesirable. There is a pertinent saying, "The first half of life one accumulates, the last half one eliminates." There are some memories and experiences, as well as material things, we do not cherish.

In Florence I was always getting mixed in my mind between the Guelphs and the Ghibellines. I managed to sort out the Primitives from the Renaissance painters, although I was a little uncertain about some of them with unfamiliar names without consulting the guide book. The craftsmen of Italy and Spain were particularly confusing. Many of the things made by them, such as wood carvings and metal work of various kinds, were so similar it was almost impossible to distinguish in which country they were made.

I had no doubt, however, about two old crosses I have that came from Florence. One was of Spanish origin easily determined by its double arms. It is a large, bronze, pendant, Reliquary Cross made about the middle of the 18th century. It probably once hung upon the wall of a private chapel in some old palace. It is of open work design of an elaborately chased pattern, and through its large openings once shown conspicuously the bones of a saint. (Page 94).

The other cross was just as obviously of Italian work-manship. It is a very beautiful, large, Processional Cross of hand carved wood, gilded in gold leaf. It is very

ornate of quite a unique design. It was probably made in Tuscany about the middle of the 17th century and may have often been carried in religious processions out from the portal of some little church among the olive slopes of Tuscany. (Page 30).

In Rome I found few crosses to add to my collection but in searching for them had a rather unusual experience. I had been wandering for hours on a fruitless quest for crosses, and indulging also my antiquarian tastes, seeing many historic monuments and ancient ruins, and came at last to the Coliseum. It was at dusk of an early evening in spring. The great amphitheater, usually deserted, was thronged with thousands of people seated on the crumbling stone seats. They were there to hear the massed choirs of the various churches of the eternal city sing ancient anthems and chants.

As I looked down upon the empty arena, I thought of those far-off days in ancient Rome when vast throngs sat upon those same tiers of stone and gazed upon the dying struggles of Christian martyrs slain by gladiators or wild beasts. A cruel, bloody spectacle—pitiless spectators.

As twilight faded into darkness, the Coliseum was illuminated by thousands of little lamps. They were open receptacles filled with olive oil and having hempen wicks —primitive and similar to the more beautiful little lamps of bronze and terra cotta used by the ancient Romans.

As the flickering wind blown, yellow flames of countless lamps illuminated the vast arena, the black-robed choristers sang the anthems and chants of the middle

ages, harmonious praises to the glory of God. It was a strangely impressive moment, the past and the present mysteriously linked but vastly different.

In the midst of this ancient ruin on the very spot where Christian martyrs had died for their faith now stands a great stone cross, a fitting memorial of their martyrdom. An aged pilgrim, it is claimed, comes twice a year to pray at the foot of this cross for the martyrs who died there.

One of the crosses I secured in Rome was a pendant cross of pearl inlaid in wood made during the latter half of the 18th century. It is of ornate design with an inlaid cross in place of the figure of the Savior. (Page 142).

Another small pendant cross was a fine example of mosaic work made about the middle of the 19th century. Upon it is the Labarum, the cross of Constantine, a most appropriate emblem for a Roman cross. (Page 142).

Neither of these crosses was found in the Rag Market where I went as I always did to similar marts in various cities. These outdoor markets of Europe, always have a lure for those in search of the quaint and the old, but crosses are rarely to be found in them.

I found several interesting crosses in France, especially in Paris. Not on the gay, thronged boulevards, but in some little shops near the Seine and in the Latin quarter.

I picked up a bronze altar crucifix made in the reign of Louis XIV, worn smooth with age and handling. I spied it in the window of a little shop, mixed up with several old pistols and daggers, strange companions. It was the only cross in the shop. Its unusual base and beautiful

floriated arms I could not resist, and added it to my collection. (Page 186).

After lunching one day at a sidewalk café, I strolled down an unknown street and discovered in an antiquary shop a very curious pendant crucifix. The bronze figure of Christ was very diminutive and hung upon a crystal background. The cross itself was dark wood. It was at least a hundred years old. (Page 78).

My search led me one day to a very interesting antiquity shop. It was presided over by a charming little antiquarian. He could speak no English and I but little French, but we struck up a pleasant acquaintance and I often visited his musty little shop filled with a dusty collection of old pictures, books and a bewildering assortment of small curios. It was the man himself who interested me, a left over relic of the time of Napoleon III with a pleasant smile and charming manners, a waxed moustache and a grey goatee. We conversed largely in signs but we were kindred souls. He recognized at once the collector's weakness in me and tempted me often with interesting and inexpensive antiques of various kinds, hidden away from unappreciative purchasers. He had a most interesting old cross I wanted but he declined all offers with a shake of the head and a friendly smile. He wished to keep it for himself. I understood his feelings; he was a collector not a mere shopkeeper. I did get from him a Pectoral Cross I prize. It was fully two hundred years old, made of tortoise shell and gold. On the bottom an incised design was used as a seal. Probably the cross was worn by some French bishop and with it he stamped his

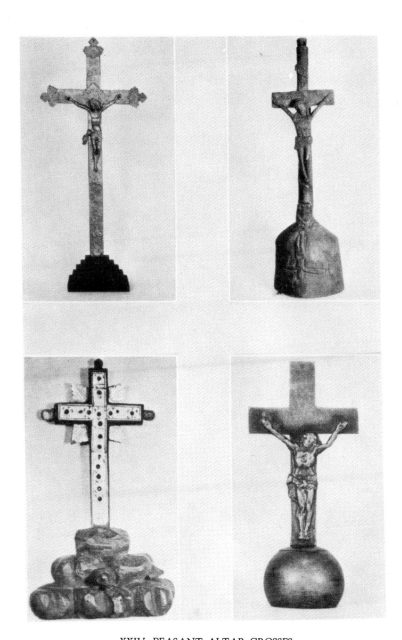

XXIV. PEASANT ALTAR CROSSES

FRENCH—*Pewter and Wood*
Elaborate Nimbus, Floriated Design
1700-1725

ITALIAN—*Pearl and Wood*
Cross of Calvary on Rocky Base
1700-1725

SICILIAN—*Carved Wood*
Base with Crucifixion of St. Peter
1675-1700

FRENCH—*Silver*
Latin Cross on Orb
1725-1750

epistles, decrees and ecclesiastical documents. (Page 62).

One must go to southern France to really visualize the past. In Provence and the mountain towns along the Mediterranean coast it is possible to see and comprehend the life and customs of centuries ago. There the inhabitants still live in the same houses built by their ancestors and pursue the same tasks and have many of their simple pleasures and customs.

Hunting for crosses is an admirable excuse for going to these interesting old towns. It is a region rich in historic memories. From some of the ancient ports on the coast the Crusaders had set sail for the Orient. At many a place had the Barbary pirates landed to plunder and slay the inhabitants. This was the reason the little walled towns were built high up on the mountain sides for defense and protection. In these ancient towns their descendants still live in the cheerless stone houses built hundreds of years ago. If I did not find many crosses in these mountain towns I was more than repaid by the glimpses I had of the primitive life and customs of the people who live in them.

At the age-worn, stone fountain in the village square women are always to be seen drawing water in copper pitchers or washing their clothes. Here and there they gathered in groups eternally knitting and gossiping. The men sat in their doorways busy at their old-time trades or loafing and chatting. The children were at play but never boisterous or laughing.

I never tired of wandering through the narrow, winding streets, and little public squares of these hillside towns

or of leaning over their fortifying walls to look down into the valley below with its shallow stream and curving roadway. From there were wonderful views of distant mountains with other little towns clinging to their olive and grape terraced sides.

Always in every mountain town there was a little stone chapel within which were one or more kneeling worshippers and on the altar a crudely made crucifix. I found just such an altar cross, probably made by a Provence peasant more than a hundred years ago. It is of blackened wood and pewter. The cross stands upon a base of five steps and upon it, the figure of the Christ is quite unusual as His head is tilted back, not, as customary, to the side. He is looking up towards heaven and has no crown of thorns but a very curious triangle nimbus. At the foot of the cross, which has floriated arms of unusual design, stands the Virgin on a crescent moon, signifying that she is the queen of the heavenly realm. (Page 166).

Another interesting old brass crucifix came from one of these ancient towns. It is no doubt of Spanish origin as it has the double arms. It is not particularly old, probably not more than a hundred years, but is of special interest because the figure of the Christ and the ornate ornamentation upon it are incised, as were the crosses made more than a thousand years previously, before the time when the figures and symbols were in bas-relief. On the reverse of this crucifix is the Virgin and above her is the head of an angel with wings outspread, in appearance much resembling the grotesque designs of the same kind to be seen on many old gravestones. (Page 78).

To this land where lived a primitive people in their mountain homes came the Romans centuries ago. The ruins of the marvelous buildings they erected still to be seen in Provence, are a remarkable contrast to the mountain towns along the coast. The ruins of temples, palaces, triumphal arches, and great amphitheaters are striking evidences that the culture and civilization of the Roman empire at the height of its power were transplanted to this foreign land. This forcibly impressed me when I was in Nîmes and saw what the Romans had built in that ancient city. I stood in the midst of that beautiful garden of the fountain with its terraces of yellow marble and green slopes above the sparkling waters. Here was a place of surpassing beauty where long ago the Romans gathered to gossip and to bathe in the spacious baths at the water's edge.

I had just been to see the Pont du Gard, that most marvelous of all Roman aqueducts, which brought the clear mountain water to these famous cascades. It spans a river valley with its impressive tiers or arches, as it has stood for nearly two thousand years. I climbed up the steep bank and stood upon its topmost arches and wondered at its beauty and enduring strength.

Near the far famed fountain in Nîmes is the great Roman amphitheater. Its circular walls of double tiers of stone arches enclose a great arena. I stood upon its stage and tried to picture the throng of spectators upon the stone seats when classic dramas were enacted there ages ago, but could only think of my own insignificance and the transitory existence of most present day architecture.

Not far away is that exquisite gem of beauty the Maison Carrée, a Corinthian temple that still stands almost unchanged in all the centuries since it was built.

There is another wonderfully beautiful creation of a past age at Orange,—the arch of triumph attributed to the Emperor Tiberius in the first century. It stands outside the town, a stately monument, its beauty outlined against the deep blue sky.

In Avignon are buildings erected long after the early Roman remains that are interesting because of their historic importance. The great papal palace is one of them. For seventy years, popes reigned in Avignon while there was no pope in Rome. In this fortress-like castle they lived until Saint Catherine of Siena persuaded Pope Gregory XI to abandon his dissolute court and to go forth and establish again the papal throne in Rome.

Beside the palace of the popes in Avignon is the cathedral and on the way up to it is an impressive Calvary. I climbed the long flight of marble steps that leads to it from the street below. Here, on the very spot where Avignon popes had stood to bless the gathered multitudes now stands a great marble cross. Upon it hangs the Savior and beneath it is the bowed figure of His mother. Surrounding the base are four kneeling angels.

From this land of beauty and historic treasures came several of my crosses. One of these is a large pendant cross of pearl inlay on wood of an intricate pattern of vine and flower, made early in the nineteenth century. (Page 142).

Another cross is a smaller pendant one of Limoges

enamel also of vine and flower design with a monogrammed center of the letters IHS. It was made about the middle of the eighteenth century, lovely in color and of the artistic workmanship that has made Limoges enamel famous for centuries past. (Page 142).

In contrast with these two beautiful French crosses are two curious peasant crosses I have, that are very crude and inartistic in workmanship. They are both made of silver and are nearly two hundred years old. They were probably both worn by peasants.

One of them is an old Russian cross of an exceedingly ornamental design with another cross superimposed. (Page 158). The other is a Balkan reliquary crucifix of a crude, intricate design. It originally held some sacred relic concealed in the back which was long since lost. (Page 158).

In England my search for old crosses was somewhat fruitless. There is no such variety of curious and artistic ones as in Italy, France and Spain, where crosses have been in demand and skilled craftsmen have been making them for centuries past.

I found one cross in London I greatly prize. It is an English silver pendant cross made one hundred years ago. It is somewhat the design of the ancient Ionic Cross, with elaborate ornamentation and the circle symbolizing eternal life. (Frontispiece).

Also a carved pearl cross made about the middle of the nineteenth century. It is very ornate with floriated arms, symbolizing the beauty and diversity of the Christian

faith. Probably at one time it ornamented the cover of a prayer book. (Page 118).

I spent several months in London, never tiring of its old-time charm. I wandered for many miles through the streets of old London, fascinated by its quaint buildings and ancient churches, built by Sir Christopher Wren, I fondly hoped. I always loitered in every little park and churchyard to rest and dream a bit about the life and customs in times long past when the gossipy Pepys walked by on his way to dine and wine with some bibulous nobleman—another item for the famous diary. Down this very street the wordy Dr. Johnson may have strolled to join his cronies for a chat in a near by coffee shop or a bite at the Cheshire Cheese. That old building across the way, once upon a time might have been a popular tobacconist's shop where debonair Beau Brummel and other gay bloods, gathered to discuss politics and their pleasures and have their snuff boxes refilled.

Up and down those old streets with their ghostly memories of the past, I wandered, poking into every curio and old book shop. There was no telling where I might find a real treasure. Rarely was it a cross. I found some very interesting pictures to add to my collection of religious prints taken out of old Bibles. They are wood cuts, copper and steel engravings, illustrations of biblical stories and characters. Some of them are more than two hundred years old and are somewhat misleading historically. In one picture soldiers in armor are bombarding with cannon the walls of Jericho. They are interesting pictorially as showing the changing ideas in Bible illustra-

tions. There are a number of pictures of the crucifixion and others featuring the cross, among my old prints.

The literal realism of some of these quaint engravings, dated 1678, is most curious. One picture depicts a group of followers of the Christ toiling up towards heaven, every one burdened with a heavy cross. An angel is holding upright a large cross and pointing the way. Another is a strangely fantastic death bed scene. Beside the dying man is a priest holding up a cross. On one side of his canopied bed is a kneeling angel and on the other a kneeling devil, contending for his soul. Death in the shape of a gruesome skeleton is entering through the doorway. Another picture is an elaborate representation of the judgment day. Archangels in the clouds are blowing trumpets. The dead are crawling out of their graves. Some are ascending to heaven guided by angels and others are being chased by devils into hell. In the heavens above is the Savior holding the cross.

In the small curio shops in the older part of London, I found only a few cheap, ornamental crosses but a motley assortment of old coins, medals, stamps, watches, false teeth and other junk.

I picked up on push carts in the slums and market squares of London a few small ornamental crosses. Among them one of Whitby jet. Whitby jet is made of a very black mineral product found among the clays of Yorkshire that takes a high polish and has been for many years extensively made into mourning jewelry at the little town of Whitby. It was probably made before 1850. (Page 134).

Black crosses for mourning were very popular about

the middle of the last century. I have several of them, very attractive in designs, made of jet, onyx, gutta-percha and rubber.

There are, doubtless, crosses of beauty and rarity to be purchased in London but I failed to find them.

There are many to be seen in the London museums. In Paris there is a small collection of very old and rare ones in the Cluny Museum. In the Metropolitan Art Museum in New York are a few unusual crosses and crucifixes dating from the 13th to the 16th centuries. The museums of nearly all the large cities of this country have a few examples of old crosses some of which are very rare and unusual, others of beauty and artistic merit.

I continued my never ceasing search in various towns in England but with small success. In Canterbury, one day, weary after many hours tramping through its fascinating streets, I stopped for a rest and a bit of lunch in an ancient inn which might have been frequented by the pilgrims who came centuries ago to the shrine of Thomas à Becket. If they did not lodge there, they must have journeyed through the very street that I had come, on their way to the ancient Canterbury cathedral. I remembered, as I sat and ate my bread and cheese and sipped my ale, that there was a legendary tale that in this very inn lodged the four knights who came to the ancient city to murder Becket back in the twelfth century. I had just come from the cathedral and had seen where he was slain, a sacred shrine still visited yearly by thousands of pilgrims. One of these had that very day laid a beautiful

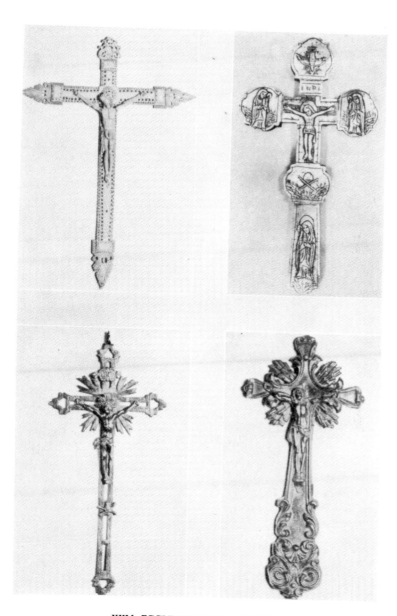

XXV. ECCLESIASTICAL CROSSES

Spanish—*Carved Ivory*
Crown of Victory instead of Thorns
1725-1750

Italian—*Bronze*
Glorified Design
1650-1675

Hungarian—*Carved Pearl*
The Dove and Three Marys
1750-1775

French—*Brass*
Rays of Glory. No Crown of Thorns
1750-1775

rose upon the stone flagging in front of the altar where he stood when stabbed by the assassins. Becket had fled into the cathedral from his palace near by, pursued by the four knights who slew him. The King had interfered with his policies and assumed authority in the government of the church. Archbishop Becket bitterly resented it and for this he was killed. He had previously been brought for trial before the Court Council and was denounced as a traitor. He denied the charge and with dramatic gesture lifted his Pectoral Cross high above his head and defied his accusers.

In this ancient town so full of reminders of a historic past I was confident I would find a real treasure. If not an archbishop's cross at least an old and curious one. By a strange twist of fate my search among the antiquary shops resulted only in getting an antique ring in which surrounded by pearls was a lock of hair. It might per-chance have been that of some old-time pilgrim to Becket's shrine or the cherished memento of some chivalrous knight, a strand of hair given to him by his lady love as a parting gift. Another interesting but less romantic find was a silver punch ladle with a long ebony handle, sug-gestive of the convivial times of the cavaliers. At last, I found a cross, but neither a very old one nor of English make. It was a small Irish cross carved out of bog oak, with the letters, IHS artistically interwoven. (Page 150).

I pursued my quest in many other towns in England, but with little success. There was plenty of historic atmosphere and antiquated buildings in them and choice pickings of old silver, Sheffield plate, lustre and Stafford-

shire ware, but antique crosses were as scarce as they are in most American cities.

My experiences on the quest for crosses may seem trivial and of little importance, but they are pleasant memories of what happened to me in many interesting places seen in my wanderings.

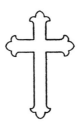

CHRIST AND THE CROSS

XXV

IN pictorial art Christ and the cross are closely associated. Not only in representations of the crucifixion but in symbolic and allegorical pictures. In them Christ is depicted either holding or standing beside the cross or with pierced hands and feet carrying it.

In sculpture this association is even more often seen, both in statues and bas-reliefs.

In the mountain pass between Chile and Argentina is a heroic statue of Christ holding a cross that can be seen for many miles. On hillsides in many lands and in numerous graveyards, are similar statues of more diminutive size. Also innumerable representations of the crucifixion are to be found in outdoor shrines and within churches and sanctuaries.

Scattered here and there throughout the Christian world are Calvaries. They are usually representations of the crucifixion and the events that preceded it. Calvary was the name of the rocky eminence outside of the walls of Jerusalem, beyond the Damascus gate, on which the crucifixion of Christ took place. High up on some hillsides, wherever possible, are placed three crosses with life-size figures, usually carved in stone, of Christ and the two

thieves with surrounding figures representing the spectators.

There are variations of this idea, and also, in the artistic merits of the various Calvaries. At Lourdes is a Calvary on the mountainside with stations of the cross, that are inartistic groups of gaudily colored statues. At the top is an enormous crucifix.

The Calvary at Aix-la-Chapelle has a church upon the hill around which are the stations of the cross, sculptured stones representing the events which occurred on the journey of Christ to Mount Calvary called Via Dolorosa.

One of the earliest Calvaries in America, which still exists, was due to the devoted labors of a Sulpician missionary, Francois Picquet, among the Canadian Indians two hundred years ago. It stands upon a lonely hillside overlooking a lake near Quebec.

On the mountain slopes of the Italian lakes, in many places amid the olive trees, are to be seen gleaming white statues and crosses, Calvaries, where pilgrims may come and worship.

In most Catholic churches are representations of the stations of the cross, either in paintings or sculptured bas-reliefs portraying twelve events in the journey of Christ to Calvary, and His crucifixion and descent from the cross. The object of these stations is to help the faithful make a pilgrimage in spirit to the scenes of Christ's suffering and death. The stations of the cross did not come into general use before the end of the 17th century.

Always in the minds of men, Christ and the cross have been closely united. During His life He more than once

spoke of the cross He must bear and declared, "And I, if I be lifted up from the earth, will draw all men unto Me."— A prophecy of His death upon the cross.

The events that led up to that tragic end have been vividly portrayed in pictures and sculptures and told even more graphically in literature.

When Christ was betrayed by Judas in the garden of Gethsemane and He was about to be seized and taken to Jerusalem to be tried, the impetuous Peter seized the sword of one of the soldiers and cut off his ear. Christ rebuked him and declared that before the cock crowed in the early morn he would thrice deny his Master. That very night, Christ was taken before the Jewish Sanhedrin, accused of blasphemy and condemned to death. All night long He was persecuted, derided, and mercilessly scourged. Then at early dawn, because they dared not crucify Him without the sanction of the Roman ruler, He was bound and led to the palace of Pontius Pilate by a procession of leaders of authority and influence, and a relentless Jewish mob.

To Pilate's inquiry as to why He was condemned to an ignominious death, His accusers declared that He was guilty of treason because He had preached against paying tribute to Caesar and had proclaimed Himself King of the Jews. Pilate questioned Him and declared he could find no wrong He had committed. But to curry favor with influential Jews he washed his hands of all responsibility and Christ was led forth to execution. A beam of the heavy cross was laid upon His shoulders and guarded by soldiers, He and two malefactors were led, accompanied

by a jeering mob, through the narrow street to the city gate. On the way, they met a Cyrenian named Simon and compelled him to carry the cross.

The tablet, bearing the ironic inscription, "Jesus of Nazareth King of the Jews," was fastened to the cross and with the blows of a mallet huge nails were driven through His hands and feet and the cross uplifted and placed in the ground. It was then, suffering great agony that Christ uttered that prayer of tender solicitude: "Father, forgive them for they know not what they do."

There in the midst of a hostile, reviling mob, He was crucified between two thieves. The soldiers cast dice for His garments. The mob mocked Him—He the King of the Jews, His throne a scaffold, His crown, one of thorns. Hours of agony passed and as darkness came and the earth trembled and the rocks were cleft, there came from His dying lips the utterance: "It is finished."

The cross has become the symbol of this tragic event and it alone suffices to make real and vital to believers the great sacrifice. Men have placed upon the cross various needless symbols. I once saw a crucifix overladen with many of these symbols.

Wandering one day through the narrow winding streets near the water front in Naples, I entered, by mere chance, an ancient church. On a side altar stood a curious metal crucifix. It was unusually large and upon it were symbols of all the events and contributory adjuncts relating to the crucifixion. The drooping figure of the Christ, crowned with thorns, nailed to a simple cross, which was cluttered with many accessories; the mallet

XXVI. EMBLEMATIC CROSSES

GREEK—*Copper*
Saints and Symbols
1825-1850
DUTCH—*Silver*
Adorned with Saints
1650-1675

ITALIAN—*Mosaic*
Symbols Dove, Anchor, Bread and Wine
1825-1850
MALTESE—*Silver*
with Elaborate Ornamentation
1825-1850

with which the nails were driven and the pincers with which they were drawn; the spear that pierced Christ's side; the chalice into which flowed the blood from the wound; the sponge upon the pole with which His thirst was quenched; the ewer that held the vinegar; the flail with which He was scourged; the sword Peter had used, and the cock that crowed to remind him of his perfidy; the vesture that was stripped from Christ when He was nailed to the cross; the dice that the soldiers cast for it; and the ladder on which He was taken down after His death. This curious inartistic crucifix with its tawdry symbols was of trivial importance compared to the simple cross itself.

Long afterwards in a junk shop in New Orleans, I found a small duplicate of this cross with the symbols of the crucifixion. It was of plated metal in all particulars the same except the size. (Page 46).

Most crucifixes have some suggestive symbols upon them. Many that appear identical, on close inspection differ in minor respects. The attitude and appearance of the Christ figure, the expression upon His face, the droop or other position of the head, the uplifted or extended arms, the crossed or the uncrossed feet, the attenuated or more rounded figure, the crown of thorns or the nimbus, and the position and the letters upon the tablet. All of these details and even the folds of the loin cloth may vary slightly.

The skull and crossbones that frequently appear on crucifixes differ sometimes very distinctively. It is a symbol interpreted as meaning Christ's triumph over death

and also as having a wider meaning that death is con-
quered for all by Christ's sacrifice and atonement for
mankind.

There is a tradition extant that Adam, through whom
the sin of disobedience first came into the world, was
buried on the very spot where Christ was crucified, and
the skull and crossbones are significant of him whom the
ancient rhyme thusly epitomized:

"In Adam's fall
We sinnéd all."

There are crucifixes in which the skull is placed in an
open rocky tomb to suggest that Adam was buried on
Golgotha. (Page 158).

On many old crosses appear symbols that have a
significance easily understood, on others the interpreta-
tion is more obscure. Certain forms of the cross have a
significance not generally known. The Floriated Cross,
the arms of which terminate in various ornamental forms,
typifies the triumph of Christ. (Page 174). This form of
cross is sometimes adorned with garlands symbolizing the
vitality and growth of the Christian religion. (Page 142).
The vine having a similar significance also appears on
some crosses and both are used as a decorative addition to
many ornamental and monumental crosses. (Page 186).

The symbols which are put upon the cross often de-
stroy its beauty and detract from its real significance.
They are as unnecessary and inconsequential as many of
the creeds and dogmas with which men have encumbered
the simple religion of Jesus Christ.

There are two unusual stone crucifixes on the Riviera.

Just outside of Nice is the old Roman town of Cimiez. It is high up on the mountainside and there, seen afar, is an ancient monastery. Within its garden walls is a huge stone crucifix erected in the thirteenth century. It is a most re-markable conception. The figure of the Christ is of heroic size with three pairs of wings back of His head and cover-ing the body. What is its symbolism, or the reason for the portrait heads of a high church dignitary and a monk on the arms of the cross, is somewhat obscure.

From the monastery wall is a sheer drop down the mountainside to Nice far below. On one of its streets still stands a great cross of stone which was erected in 1536. It is a curious representation of the crucifixion with a canopy supported by four great columns over the huge cross. On its extremities are the heads of the four Evangelists.

All of the Calvaries and outdoor crosses of stone and marble are visible reminders to men of the Savior who died for them. Many there are who heed them not but who see above the skyline of modern materialism the invisible cross.

THE MYSTICISM OF THE CROSS
XXVI

THE cross has always had a distinctive significance and a mystic influence on the Christian world. The thoughts and beliefs of men about it have crystallized into proverbs often spoken and written that have become a treasured heritage of the past.

Some of these proverbs are obvious truths, such as: "Every man must carry his own cross," while others are curious phrases with suggestive touches, such as: "No man hath a velvet cross."

There is another old proverb which thus tersely suggests: "Make a crutch of your cross." While still another quaintly affirms the well-known truth: "Everyone thinks his own the heaviest cross."

A most spiritual uplift is in this ancient proverb: "No cross, no crown." A similar thought is expressed in another proverb in this way: "He that has no cross, deserves no crown."

Still another proverb asserts: "Crosses are ladders that do lead to Heaven." Another wise axiom declared: "In the cross thou shalt conquer," which truism some ancient writer puts more poetically—"The cross if rightly borne shall be no burden, but support to thee."

These are a few only of many proverbs that have the cross as their subject.

Around the cross are woven some curious ancient legends. One of these is of the dogwood blossoms that in shape resemble the Greek Cross. On the tip of each blossom is a mutilated spot and according to the legend little devils tried to destroy the blossoms because they resembled the cross, but only succeeded in marring their beauty and symmetry.

Among the mountains in the southwestern part of Virginia are found small stone crosses of a brown material called staurolite from the Greek word stauros, a cross, which crystallize into small cruciform shapes. They are called Fairy Crosses. There is a legend that they were the tears of the fairies shed when they heard of the crucifixion.

They are neither of fairy origin nor are they carved by the hand of man. They may have some mystic significance. There are many things in life that are unknowable and inexplicable. One of these is the undeniable and marvelous influence of the cross upon human lives and characters. Many a devout believer has proved the truth of that ancient proverb: "The way of the cross is the way of light."

This mystic significance of the cross is incomprehensible to many. The command of Jesus Christ that he who would become His disciple must take up his cross and follow Him, is often misunderstood and misinterpreted. The cross means to one man service and to another sacrifice. The rich young ruler who came to Christ to make inquiry how he could gain a fuller life, truthfully claimed that he had

always been righteous and law abiding, but when Christ asked him to carry a heavier cross, to give up power and riches, it was too great a sacrifice, and he went away sorrowful.

George F. Watts, the great English painter, graphically portrayed him at the moment when he turns away, with averted face and bowed figure, eloquent of his contrition and regret that he could not do what Christ commanded.

Many years ago Mr. Watts gave me a gift I greatly prize, a book about him and his art, containing a beautiful reproduction of this picture and many others that he painted of great spiritual inspiration and suggestive symbolism.

Nineteen hundred years ago a simple, wooden cross was erected on Calvary. Today it is of more widespread significance and importance than any other emblem or symbol in the world. There are said to be over four hundred varied forms of that simple wooden cross, but even more numerous and of greater significance are the Christian ideals and ethics it represents. Its material forms and designs are the creation of the artist and the sculptor. Its vital meaning and value is the message it brings to all men whatever their belief or philosophy. A message of salvation by faith, service and sacrifice. The cross would long ago have been discarded and forgotten as the emblem of Christianity were it not for its imperishable and revivifying meaning.

The curious symbols that men placed upon the crosses they made in ages past are of little value or significance, except that they crudely expressed the inarticulate thoughts

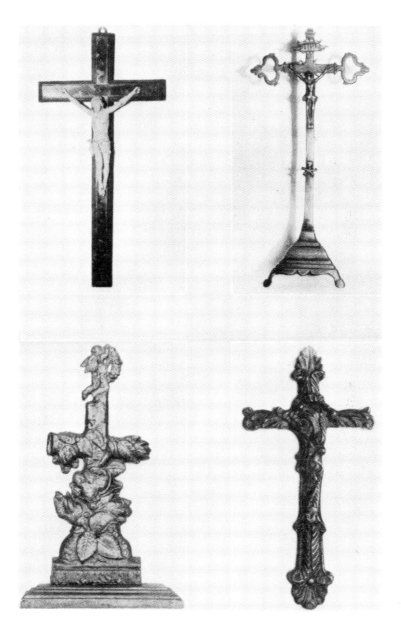

XXVII. UNUSUAL CROSSES

SICILIAN—*Ivory. Tortoise Shell*
Beautiful Wall Cross
1750-1775
AMERICAN—*Brass*
Curious Floral Design
1850-1875

FRENCH—*Bronze*
Floriated Altar Cross
1700-1725
SWISS—*Bronze*
Cross Used Outside of Tomb
1800-1825

and beliefs that still cling around the Christian Cross.

It has by no means become an obsolete and discarded emblem. Never in all recorded history has the cross been used as extensively as it is today. Somewhere upon the exteriors and within the walls of almost all churches, regardless of creed, the cross is to be seen. In every churchyard and burial ground in our land and in all other Christian countries there are an innumerable number and variety of crosses that proclaim the faith and mark the resting places of the dead.

Now, as in the past, great crosses of granite and marble are being erected as appropriate memorials of sacrifice and victory. In times long past it was the custom to raise a cross to commemorate the successful end of a voyage of discovery. Even no longer ago than September 6, 1932, in Grant Park, Chicago, there was erected a cross on the very spot where on that day, fourteen years before, safely landed the first mail plane that flew from New York to the great city of the mid-west.

The crosses of wood and stone and bronze that have been, and are still being erected, are reminders to thoughtless and heedless men and women of Him who endured the shame and suffering and death upon a cross. About the life and death of Jesus Christ cluster all the meaning and mysticism of the cross.

THE MEANING OF THE CROSS
XXVII

CHRIST admonished His disciples that if they would be His followers they must carry the cross. His command probably had little meaning to them. They did not then comprehend that the cross was symbolic. It was the cross of sacrifice and self-denial they were to bear. Christ proclaimed that it was God's will that all who believed and followed Him must endure the cross of sorrow or misfortune patiently and uncomplainingly. Even the loss of health or property or the death of loved ones must be borne without bitterness or complaint. In Gethsemane, shortly before He died upon the cross, Christ pleaded that He might be spared the cup of suffering and sacrifice, but ended His prayer with the inspiring words, "Thy will be done." Doing God's will often means the loss of personal gain or pleasure. It is sacrifice for others. This is bearing the cross of Christ.

For centuries past the cross has stood upon the altars and surmounted the spires and pinnacles of churches. It has hung upon the walls of great cathedrals, beautiful palaces, and humble homes. In nearly every public square and wayside shrine there is a cross. This is as it has been in nearly every city and town in Europe for a thousand

years and more, and, as it is today. The crosses may have been erected centuries ago, but they are still there, and many people, as they pass by, cross themselves or whisper a prayer. Thousands of devout men and women still cherish their crosses.

Through the streets of the old world today as centuries ago, with great pomp and pageantry, chanting priests and choristers in richly embroidered robes and with gorgeous banners carry in spectacular processions this symbol of the meek and lowly Nazarene.

The world has always done queer, unbelievable things in His name. The tortures, the persecutions, the inquisitions, the crusades, doctrinal disagreements, heresies, religious wars—all in the name of Christ. Foolish zeal and wicked waste of effort they seem to us today. And yet they were all considered wise and righteous at the time.

The tremendous amount of cruelty, suffering, injustice, and bloodshed done in the past in the name of the Cross seems incredible and monstrous.

Men have always stumbled on the way to better things and will doubtless still blunder on. The wisdom of one generation has seemed foolishness to the next.

The simple things of Christ's teaching have been the hard things to learn. All through the ages the Cross has been a symbol only half understood. Men thought it meant redemption through faith. They are only just beginning to learn its wider, deeper significance—redemption through sacrifice and service. It is not alone sufficient to believe, but to serve.

Christ said to His disciples," Follow Me." His, was a

life of service and sacrifice. This has always been and ever will be *via crucis*—the way of the Cross.

There is deep spiritual significance in Christ's saying, "Consider the lilies of the field, how they grow; they toil not, neither do they spin—yet Solomon in all his glory was not arrayed like one of these." It is symbolic of man's spiritual life. The roots of the lily are in the earth. Its beauty and fragrance the outgrowth of God's beneficent sunshine. The Cross planted in shame and ignominy has grown through the ages in the hearts of men to become the symbol in mystic beauty and power of the Spirit of Jesus Christ.

Symbols

SYMBOLS USED ON THE CROSS
AND IN CHRISTIAN ART

Alpha and *Omega*—The first and last letters of the Greek alphabet—emblem of the eternity of Christ. "I am Alpha and Omega, the beginning and the end, the first and the last."

Anchor—Symbol of Hope, also of Steadfastness. "Which hope we have is an anchor of the soul, both sure and steadfast."

Angels—Messengers of God.

Apple—Emblem of the fall of man. Held in the hand of the infant Christ signifies Redemption.

Banner—Symbol of Victory. When carried by warrior saints signifies Victory over the powers of evil. When borne by the Lamb, Victory through Sacrifice.

Cross—The emblem of Christianity, symbolizing the sacrifice and atonement of Jesus Christ.

Crown—Symbol of Power and Sovereignty. When worn by martyrs symbolic of Victory through suffering and sacrifice.

Crown of Thorns—Symbol of the Savior's passion.

Candelabrum—Symbol of Christ and His Church. Also the seven branch candlestick is symbolic of the Holy Spirit, the source of all illumination and interpretation of God's truth to man.

Chalice—Symbol of the blood of Christ shed for the redemption of all men.

Circles—Of equal size, interlaced, symbolize the equality of the Trinity, bound together in unity. Circles signify Eternity without beginning or end.

Dove—Symbol of the Holy Spirit which descended upon Christ "in bodily shape like a Dove."

Dragon—Symbol of Sin, Evil, Temptation and Paganism. Warrior Saints are pictured valorously fighting the Dragon.

Evangelists' Symbols—The Man, St. Matthew, the Lion, St. Mark, the Ox, St. Luke, and the Eagle, St. John. The Eagle is also symbolic of inspiration and spirituality, suggested by the heavenward flight of the eagle.

Fish—An early symbol of Christianity. Three fishes interlaced is symbolic of Baptism, which is always administered in the name of the Father, the Son and the Holy Spirit.

Fire or *Flames*—Symbolize great religious fervor or piety. Also characterize martyrdom.

Globe—Held in the hand of Christ symbolizes his sovereignty over the world. The Cross surmounting the Globe signifies the supremacy of the spiritual over the material world.

God the Father—Represented by the symbol of a Hand pointing downward in blessing either in the midst of a cloud, or in a circle enclosing a cross. Another symbol is a triangle in which appears the word Jehovah in Hebrew letters placed within a radiating circle or halo, symbolizing eternity. God the Father is also represented as a

venerable man usually surrounded by angelic heads.

I H S—Abbreviated form of the Greek word for Jesus. It is more frequently interpreted to represent the Latin words *Iesus Hominum Salvator*—"Jesus the Savior of men." Frequently appears on crosses and crucifixes.

I N R I—These letters stand for the Latin inscription *Iesus Nazarenus Rex Iudaeorum*—"Jesus of Nazareth the King of the Jews," which Pilate ordered placed upon the cross on which He was crucified.

Lamb—Symbol of Jesus Christ, the Sacrificial Lamb, derived from the words of John the Baptist—"Behold the Lamb of God which taketh away the sin of the world." The symbol is a Lamb sometimes with a nimbus about the head, bearing a cross, symbolic of sacrifice, and a banner signifying triumph over death.

Laurel—The laurel wreath worn by conquerors, poets and philosophers is the emblem of triumph and glory for the Christian who had "fought a good fight and finished his course."

Lily—Symbol of Purity and Virtue. Also of the Resurrection.

Lion—Symbol of Christ who was called the Lion of the Tribe of Judah.

Lamp—Symbol of Wisdom and Piety. The Taper and Lantern have much the same significance.

Olive Branch—Symbol of Peace and Reconciliation.

Oak—Symbolic of Strength. Oak leaves and acorns are decoratively used on monumental crosses.

Palm—Emblem of Victory. Christian martyrs are usually represented holding a palm branch.

Pomegranate—Emblem of Immortality.

Phoenix—A symbol of Immortality. The fabulous bird of antiquity that was consumed by fire and rose to life again from its ashes became a Christian symbol of Immortality and Resurrection.

Pelican—Symbol of Christ's sacrifice. The bird that the ancients believed tore open her breast to feed her young with her own blood was supposed to typify the blood shed by Christ to give spiritual life to all believers.

Passion Flower—Symbolic of the passion of Christ. Used ornamentally on monumental crosses and in pictorial art.

Peacock—An early symbol of Immortality. Later symbolic of Vanity and Vainglory.

Pigeon—An early symbol of the Soul and of Vigilance.

Rose—Symbolic of sacred Love. The flower of women saints and martyrs.

Skull—Symbolizes Penance if beside a saint. The Skull and Crossbones are symbolic of Death.

Star—A symbol of Christ, derived from the saying:— "I am the root and the offspring of David, and the bright and morning star." The five-pointed star, representing the star of Bethlehem, is a Christmas emblem. The six-pointed star symbolizes the Creator, the double triangle of which it is composed represents the elements, fire and water.

Serpent—Early symbol of Sin and also of Wisdom.

Staff, Gourd and *Shell*—All symbols of Pilgrim Saints.

Sword—Symbolic of spiritual not material warfare. "The sword of the Spirit which is the Word of God."

Triangle and *Trefoil*—Emblems of the Trinity, symbolic of Equality and Unity. Sometimes the triangles are intersected or the trefoil united with the triangle.

Vine—Symbol of Jesus Christ who declared, "I am the vine, ye are the branches." A symbol much used on monumental crosses.

This list includes nearly all of the important symbols used on the Cross and in religious art. There are other less familiar and significant symbols.